WITH THE COMPLIMENTS
OF
THE INTERNATIONAL CULTURAL SOCIETY OF KOREA
C.P.O. BOX 2147 SEOUL, KOREA

Traditional
KOREAN PAINTING

Traditional
KOREAN PAINTING

Edited by
the Korean National Commission for
UNESCO

The Si-sa-yong-o-sa Publishers, Inc., Korea
Pace International Research, Inc., U.S.A.

Published simultaneously in KOREA and the UNITED STATES

KOREA EDITION
First printing 1983
The Si-sa-yong-o-sa Publishers, Inc.
5-3 Kwanchol-dong, Chongno-ku
Seoul 110, Korea

U.S. EDITION
First printing 1983
Pace International Research, Inc.
Tide Avenue, Falcon Cove
P.O. Box 51, Arch Cape
Oregon 97102, U.S.A.

ISBN: 0-89209-015-4

This series is a co-publication by The Si-sa-yong-o-sa Publishers, Inc.
and The International Communication Foundation.

Foreword

The Korean people are artistic, expressing their inner-most being in pottery, painting, poetry, drama, music and dance. To most foreigners familiar with Chinese and Japanese art, Korean art comes as a profound revelation and a delightful experience. Korean art differs from the strong, bold aspects of continental Chinese art and from the dazzling colours of Japanese art. Its basic characteristic is simplicity, reinforced by the atmosphere of quiet and serenity which it creates.

Following the publication of *Modern Korean Short Stories*, the Korean National Commission for UNESCO embarked upon a new project, dedicated to seeking real character of Korean culture. This new series deals with various aspects of Korean culture—language, thought, fine arts, music, dance, theatre and cinema, etc. It concentrates on baring the roots of the Korean cultural tradition and demonstrating the process of its transformation. It is hoped in this way to reveal the framework of traditional thought which is fundamental to any understanding of Korea's past and present.

Profound thanks are due to the writers of the individual articles and to the generous sponsorship of the Si-sa-yong-o-sa Publishers, Inc., who once again have turned a dream

into a reality. This series, edited by the Korean National Commission for UNESCO, is published by the Si-sa-yong-o-sa Publishers, Inc., in commemoration of the thirtieth anniversary of the Korean National Commission for UNESCO.

Bong Shik Park
Secretary-General
The Korean National Commission
for UNESCO

Contents

Contents

Traditional
KOREAN PAINTING

Korean Painting

CH'OE SUN-U

Korean painting has been strongly influenced by Chinese painting since its initial period, because of the geographical proximity of the two countries and their long-standing historical cultural ties. Both the subject matter and the philosophical background of Korean painting, as well as its various styles, had naturally long been subject to Chinese fine arts on the whole.

On the other hand, however, Korean artists early developed unique characteristics by harmonizing in a spontaneous manner the Chinese style with the roots of the nation's original artistic impulses influenced by special features of the Korean peninsula. Korean painters sought the uniqueness of their own art; it is generally characterized by a loose and carefree expression, light colors, the charm of diffuseness, and the beauty of innocence. When combined they give Korean painting the quality of being unostentatious.

This special quality became more pronounced as years passed; it took firm root as an unmistakable national style in the latter part of the Yi dynasty period.

Three Kingdoms Period

Koguryŏ

The earliest remains of Korean painting are found in the

1

murals of ancient Koguryŏ tombs. The early Koguryŏ kingdom had contacts with north Asian civilization through peripheral tribesmen such as the Huns.

The influence of the north Chinese culture (Han and Six Dynasties periods) was dominant in Koguryŏ culture. The Koguryŏ people as horse-riding tribesmen had to fight their enemies constantly on the bleak plains and amid the rugged mountains of southern Manchuria and northern Korea. This spirit is reproduced vividly in the forceful lines and lively themes of the murals.

Koguryŏ tombs decorated with murals are distributed mainly in two areas — along the Taedong River around P'yŏngyang and along the Yalu River around the Tungkou Basin in Chian Prefecture of Manchuria. Murals are found only in tombs covered with earth. They can be classified into two groups — those painted directly on the stone walls of the burial chambers, and those painted on walls plastered with lime when the stones were coarse. Both are truth frescoes.

The main themes of Koguryŏ tomb murals suggest prayers for the repose of the dead, hope for as happy a life in the other world, and for their rebirth into this world. They are thus in the nature of an epitaph. To enrich the life of the dead in the other world, the murals symbolize a small cosmos. They depict clouds, sun, moon, and stars, as well as images of the four nature gods who were believed to govern both time and space — the Blue Dragon (on the east wall), the White Tiger (on the west wall), the Red Phoenix (on the south wall), and the Black Tortoise (on the north wall).

In many cases the murals describe the personal history of those buried, with portraits of the dead man, his wife, his concubines, scenes of dances, banquets, hunting, or battles. These were a sort of epitaph in the form of pictures. Many other murals deal with a motley of elements of ancient Chinese thought, Northeast Asian folk faith, and Buddhism. They range from reverence of heaven and worship of spirits to faith in heavenly and earthly gods and magical formulas. Others

show patterns and architectural structures. From these we can presume multifarious influences came from different sources of foreign culture exerted on the Koguryŏ people.

As in the case of early paintings of any other race, Koguryŏ tomb murals of the fourth and fifth century are clumsy in expression, ignoring the relative size of big and small objects and the rules of perspective. Not a few of them lack frontal delineation of movements and objects.

In the latter half of the sixth century, however, Koguryŏ murals began to cast off the style of arranging objects in a row which is peculiar to primitive painting. The schematized style of arranging things in a row began to change and the first instance of this transformation can be found in murals of hunting showing herds of lively animals, a theme reflecting nomadic tribesmen.

Having gone through this stage, the Koguryŏ people began to produce truly great murals toward the close of the sixth century, masterpieces which kept pace with the development of painting in China. Good examples are the murals of the Four Gods and forests discovered in the Large and Medium Tombs in Sammyo-ri, Kangsŏ and in Tomb No. 7 in Chinp'a-ri, Chunghwa (both in South P'yŏng-an Province).

The murals show what it is the high cultural standard that the Koguryŏ people had achieved. This mural style, after its introduction to Paekche and Silla, also exerted a strong and lasting influence on tombs of north Kyushu and the Asuka tombs of Japan. Even the eighth century Takamatsu tomb echoes this style very clearly.

Paekche

Having constantly kept direct contact with south Chinese culture by sea since the fourth century, Paekche could rapidly absorb the Southern Dynasty painting style of China, thereby laying a foundation for the future development of its own painting art. Paekche at the same time also continued the

Koguryŏ style it had already imported from the north.

One record shows that Paekche asked the South Chinese kingdom of Liang in 541 to send painters and artisans. The brick tomb dating back to the sixth century located in Songsan-ni, Kongju, retains murals in which the Four Gods and the stars are painted in a dynamic manner. In the stone tomb located in Nŭngsan-ni, Puyŏ (c. 700) are murals showing very refined lotus flower and cloud patterns, stars, and portraits of the Four Gods which remind one of the murals of the Great Tomb in Sammyo-ri, Kangsŏ, South P'yŏngan Province.

Evidently retaining the influence of the style of Koguryŏ tomb murals are the delicate pictures of lotus flowers and Red Phoenix drawn in color together with animal deities on the wooden pillow and foot rests belonging to the queen in the tomb of Paekche King Muryŏng and his queen (constructed in the first half of the sixth century) in Kongju in 1971.

Japanese historical records frequently mention Koguryŏ and Paekche painters, which indicates that painters of the three Korean kingdoms made a significant contribution to the development of Japanese painting in its initial or Asuka period.

Paekche painters who went to Japan or whose works were introduced to the insular country include Paekka, Hasong, Insarabol, Sangnyang, and Prince Ajwa. The portrait of Japanese Prince Shotoku attributed to Prince Ajwa preserved at Horyu-ji Temple in Nara, Japan, reflects the Six Dynasties style of portraiture as used in Paekche. Some believe that this piece is an imitation made during the Nara period; even so it suggests that through Paekche Chinese style painting had a deep influence on Japan.

It is presumed that Paekche achieved great progress in various genres such as Buddhist painting, portraiture, and landscape painting by the sixth or seventh century, as evidenced by the excellent landscape painting on bricks discovered at the site of a ruined Paekche temple dating back

to the first half of the seventh century located in Kyuam-myŏn, Puyŏ.

Old Silla

The paintings of Silla had been recognized as most conservative among the three ancient Korean kingdoms. Not a single surviving item was found until the 1950's. In 1963 a mural of lotus flowers, still fresh in color, was uncovered in an Old Silla tomb in Koryŏng, South Kyŏngsang Province. In 1971 murals showing human figures and lotus flowers were discovered which date them in the sixth century, following the style of the Koguryŏ murals. In 1973 Old Silla paintings were discovered unexpectedly in Kyŏngju's Tomb No. 155. They suggest the strong influence of Koguryŏ's tomb culture on ancient Silla tombs.

These paintings of divine horses, human figures on horseback, and divine animals drawn on the surface of handicraft articles made of white birch bark are new and valuable materials for research on the history of Silla painting. A kind of oil painting, they indicate that the contours were first drawn with relatively liberal lines and then colors were added. Especially noteworthy is the fact that a mural similar to the Old Silla tomb picture of divine horses is found on the ceiling of the Muyongch'ong tomb in Tungkou. Also this picture of divine animals shows a style strikingly similar to that embodied in the pictures of red phoenix in the Large and Medium tombs in Uhyŏn-ni, Kangsŏ.

No other Old Silla paintings survived except these rather fragmentary tomb materials. However, we find in *Samguk Sagi* (Historical Records of the Three Kingdoms) a brief biography of Solgŏ, active from the mid sixth to early seventh century, who is described as a painter of genius.

Unified Silla Period

The unification of the Three Kingdoms by Silla in the middle of the seventh century integrated their arts which had been developing independently of each other into the sphere of Silla culture, resulting in the rise of a unified national culture.

Due to the cultural ties with China which became closer after the unification, T'ang painting must have exerted a fresh influence on the painting of Unified Silla. Unfortunately, however, we have no remains of Unified Silla painting nor even records with which we may clarify its style, except one contained in *Samguk Sagi*, which says that there was a government office named Ch'aejŏn during the reign of King Kyŏngdŏk and we may presume that this was in charge of painting.

Buddhist paintings and murals executed by Korean artists are in many cases accredited by oral tradition to Wu Tao-hsuan (Wu Tao-tzu) of T'ang; this indicates the strong influence of the great Chinese Buddhist painter on Silla painting.

Koryŏ Period

An office exclusively in charge of painting was established in the Koryŏ court, patterned after the practice of the Chinese Sung rulers. Two schools existed during Koryŏ — one comprising professional painters and the other aristocrats, scholars, and literati who regarded painting as a hobby.

The division was more due to their social standing than differences in their style of painting. Monarchs (including and after King Ch'ungsŏn), aristocrats, scholars, literati, and priests enjoyed India-ink painting, drawing birds and animals, flowers, and the four gracious plants (plum-blossom, orchid, chrysanthemum, and bamboo), and even portraiture and Buddhist painting.

Among literati painters who enjoyed painting as an intellectual hobby were Chŏng Chi-sang (?-1135) who won fame for his landscapes and drawings of flowers, priests Haeae and Hyeho, masters of Buddhist painting who were also proficient in drawing bamboo in Indian ink, and King Kongmin (r. 1351-1374), who excelled in landscape painting, portraiture, and drawing flowers and birds. Especially King Kongmin, an extremely cultured man, was a painter-king whose artistic excellence is compared to Emperor Huitsung of North Sung. The Chinese emperor was especially masterly in drawing flowers and birds and in portrait painting after the North Sung academic style. His palace collection of Chinese paintings was the largest assembled to date. It exerted far-reaching influence on the promotion of Koryŏ painting.

Professional painters representative of the Koryŏ period included Yi Nyŏng (c. 12th century), who was greatly renowned for his excellence in landscape painting. His two landscapes, one of the Yesŏng River and the other on Ch'ŏnsuwŏn Pavilion, won great praise from Emperor Huitsung who actually led his country's Academy of Painting, as *Koryŏ-sa* notes.

Evident remains of Koryŏ painting which are extant today include the following: the pictures of the Four Gods and the Twelve Oriental Zodiacal Divine Animals painted on the walls of the tomb (11th or 12th century) in Surakam-dong, Kaesŏng; the Pŏptangbang Tomb (13th century) in Changdan; and King Kongmin's tomb (1374) in Kaesŏng, all unmistakably retaining the Koguryŏ tomb mural tradition; the portraits of Bodhisattva and Deva-Kings (1377) drawn on the walls of Chosadang Hall in Pusŏk-sa Temple in Yŏng-ju; and the drawings of water flowers and wild grass (14th century) painted on the walls of Sudŏk-sa Temple in Yesan. In addition a 1971 discovery revealed in the Koryŏ tomb (11th or 12th century) located in Kŏch'ang, South Kyŏngsang Province, portraits of the Twelve Oriental Zodiacal Divine Animals and the Four Gods, and drawings of human figures playing musical in-

struments and dancing.

These Koryŏ tomb murals retain the lingering influence of the Koguryŏ tomb culture; one transformation is that the Twelve Oriental Zodiacal Divine Animals emerged as the main theme, while the Four Gods dropped into secondary position. These Koryŏ murals, both those on the walls of tombs and those on the walls of temples, show contours which are formed with smooth flowing lines and bright colors depicting the figures they represent.

The Koryŏ characteristics displayed in painting were attractive enough to draw favorable comments from foreign critics. Koryŏ paintings of the 13th and 14th centuries such as those preserved at Japanese temples are magnificent and rich in originality, truly deserving the praise extended by Kuo Jo-hsu. They include a landscape of summer produced by Ko Yŏn-hwi and preserved at Chion-in in Kyoto, a landscape in Indian-ink preserved at Sokoku-ji in Kyoto, and a picture of the Goddess of Mercy under willow trees executed by Hyeho and kept at Asakusa-ji in Tokyo.

Yi Dynasty Period

The energy arising from the establishment of a new dynasty and its strong will to cultural re-construction enabled the capital city Seoul to found a new basis for painting during the reign of King Sejong (1418-1450). By that time the structure of the Tohwa-sŏ (Office of Painting) had already been reorganized, training young men talented in painting. These professional painters whose activities centered around the office formed a school of their own, while aristocrats, scholars, literati, ranking bureaucrats, and other intellectuals gave rise to a genre known as literati painting.

Although the division of painting into the two schools was a practice handed down from the preceding Koryŏ period, the trend became more conspicuous in the Yi kingdom. Among

royal relatives, ranking courtiers, and literati who were excellent in drawing nature, flowers, birds, and the four gracious plants during the period from the foundation of the dynasty to the end of the 16th century were: Kang Hŭi-an (1417-1464), Yi Am (1499-?), Madame Shin Saimdang (1512-1559), Shin Se-rim (1512-?), Yi Chŏng (1541-1622), Kim Che (mid-16th century), and Yi Kyŏng-yun (1545-?).

Especially Yi Am, Shin Se-rim, and Yi Chŏng produced India-ink pictures which are plain, unbridled, impromptu, and subtle, forming the fundamentals of Yi dynasty literati painting. They freely gave expression to their artistic disposition, unfettered by the old practices in the conservative art world which until the early half of the 16th century was still confined to the academician style of North and South Sung.

Madame Shin Saimdang, the mother of Yi Yi, the greatest scholar of his time, displayed her delicate sensibility in drawing grass, insects, and grapes in a lyrical fashion. She became the first woman painter who described the Korean climate so well.

Together with these literati-painters who enjoyed painting as a hobby, a group of prominent professional painters emerged, their activities centering mainly around the Office of Painting. They included landscapist An Kyŏn (1418-?), who retained the style of Kuo Hsi of North Sung and landscapist Yi Sang-jwa who showed influence from the style of Ma Yüan, a great South Sung landscapist. Both exerted dominant influence on the conservative art world of Seoul until the first part of the 16th century. In other words, An Kyŏn and Yi Sang-jwa, together with Kang Hŭi-an, were leading landscapists in the early Yi dynasty period; and tne ıact that they were still confined to the old style of Sung academician-ism illustrates how conservative the taste of the royal court and nobility still was. This means that painters flattered the conservative taste of the upper-class people who still revered Sung culture.

Making a contribution to the rise of this conservative trend, it is believed, was the enormous collection of Sung and Yüan paintings of Prince Anp'yŏng (1418-1453), the fourth son of King Sejong. Apparently, he possessed almost all of the Chinese paintings which were once in the collection of Koryŏ King Kongmin.

The residence of Prince Anp'yŏng, a young man of refined taste who was very fond of learning and artistic pursuits, was frequently visited by eminent scholars and literati, An Kyŏn among them. Presumably his collection of Chinese paintings impressed leading artists like An Kyŏn.

At the same time a group of painters, Kim Che, Yi Pul-hae, and Yi Kyŏng-yun among them, brought to Seoul's art scene the Northern School style which included the academicianism of Ming and the Che style.

The war of aggression launched by Japan against Korea in the closing years of the 16th century reduced almost all parts of the country to ashes as the hostilities raged up and down the peninsula. The succeeding Manchurian invasion also dealt a severe blow to the Seoul art world.

In the 18th century, the Seoul art world showed remarkable activity with the emergence of noted painters such as landscapist Chŏng Sŏn (1676-1759). He adopted the Southern School style for sketches of Korean nature. He explored a new pattern for unique Korean landscape painting. Conventional painters of his time first copied Chinese albums and were satisfied with their imaginary landscape paintings. Chŏng's landscape paintings resulted from his awakening to national consciousness as a pioneer artist.

Kim Hong-do (1760-?), who indirectly inherited Chŏng's achievements, appreciated Korean nature with true love, and completed what is called "Tanwŏn's landscape style".

Exploring a new phase in genre painting were Kim Hong-do and Sin Yun-bok (latter 18th century to early 19th century), who boldly described the occupations and loves of common people. The exploration of themes depicting the joys of work

and love in the life of common folk was a result of shifting their attention to commoners. This was a bold attempt at the time when it was customary for painters to deal only with high-brow and idealistic themes. Their work can also be understood as an expression of a social awakening though still not consciously so.

This genre painting, which emerged simultaneously with the rise of popular literature employing only Han'gŭl, described a world which had been neglected by conventional painters when they selected their themes. This new art recorded the life mode of the Yi people, above and beyond their value as art works.

Upon closer analysis, however, Sim, as is the case with Yi In-mu, depended too heavily upon the spirit dominant in Ch'ing art which mainly succeeded the Wu school. Therefore, they regrettably failed to give full expression to their originality as Korean painters. Pyŏn Sang-byŏk opened up a new path for depicting animals such as cats and chickens, and he displayed an exceptional talent in describing the life mode of cats with impressive realism. That he could sketch cats so realistically was due to his long observation of the animal with deep affection.

Coming from very humble and low families, both Yi Chae-gwan and Chang Sŭng-ŏp learned painting almost entirely by self-study; later, however, they displayed great ability to such an extent that they are regarded as representative artists of their age. Yi's series of paintings on the theme of human figures under pine trees show his employment of shaded India-ink to produce the effect of being smooth yet profound. He attracted attention as a landscapist whose sensibility was compared to that of Ch'ing landscapists who set a pleasant background in paintings of mountains and rivers.

Chang Sŭng-ŏp was a painter who decorated the last period of Yi dynasty painting. An artist of genius he entered maturity in all genres of painting ranging from landscape painting after the purely Southern School style to the Ch'ing style which

belonged to the Northern School and including human figures, and flowers. Simultaneously with the emergence of these professional painters, literati-painters flourished.

The skills of Western painting were first introduced to Seoul art in the closing years of the 18th century or the early years of the 19th century. It is presumed that information on the painting of Italian Catholic missionary Nang Se-nyŏng (Korean transliteration, 1668-1766), who won fame in Peking for his painting, and other European artists may have been brought back to Korea. One example of Korean works showing Western influence is a painting of a dog now kept at the National Museum of Korea. In 1900 a French painter-ceramist by the name of Remion came to Seoul and his oil paintings greatly stimulated Korean painters who were in the so-called period of enlightenment.

One of the noteworthy developments in the Seoul art world at the time was the development of portraiture. Professional painters who were employed at the Office of Painting were in charge of producing these. The practice emerged of having the king and meritorious retainers portrayed, and to copy portraits of ancestors for enshrinement at family shrines.

The skill of Yi dynasty portraiture was very realistic, and it was believed that the ideal was to draw not only the countenance of the person to be portrayed in a realistic manner, but that the portrait should also describe his refinement, personality, and character. Portrait painting became most refined in the 18th century, and its representative work is the portrait of Yi Chae now preserved at the National Museum of Korea. It was customary that portrait painters did not place their signatures on the works they produced, and so their names are known only rarely.

Two Korean Landscape Paintings of the First Half of the 16th Century

AN HWI-JUN

General Survey

It seems necessary to survey beforehand general aspects of Korean landscape painting of the first half of the sixteenth century to enhance our understanding of the two paintings which will be studied later.

Most extant Korean landscape paintings of the first half of the sixteenth century were executed to order for scholar-officials by academy painters who, being men of relatively low social status, seldom signed their paintings and were hardly recorded in official histories. Thus with a few exceptions the works are not signed, nor do they bear a painter's seal, so that the authorship of the paintings is an almost insoluble problem.

Of the landscape painters active in the period, only a few names are known from literature.[1] The scholar-painter Yang P'aeng-son (1488-1545) is traditionally known to have followed the An Kyŏn style[2] which had developed out of the so-called Kuo Hsi tradition, a landscape tradition formed by the Northern Sung Chinese master Kuo Hsi and his followers. This is shown by Yang's only existing landscape *(Fig. 1)*, which will be discussed in detail later. Although Yang's friend Sin Cham (1491-1554) is better known for his ink bamboo paintings, one landscape, which has something to do with Ming court style, is attributed to him.[3] Madam Sin Saimdang (1504-1551) was recorded as a follower of An Kyŏn in

13

landscape painting, but no authenticated landscape by her is now in existence.⁴ Several paintings attributed to her are of such subjects as grapes, bamboos, flowers, and swimming ducks. Kim Che preferred to paint water buffaloes in landscape setting in the Southern Sung academy style.⁵ We have no idea at all on what styles the other scholar-painters painted.

The academy painter Yi Sang-jwa had considerable fame as a painter. Originally the slave of a scholar-official, he was emancipated and appointed to the Academy of Painting by King Chungjong (r. 1506-1544), who recognized his talent. He excelled in portraits, figures, and landscapes. Again, no authenticated landscape by him is extant, but a hanging scroll entitled A *Stroll under the Pine tree* at the National Museum of Korea is traditionally attributed to him *(Fig. 2)*. Unsigned and bearing no seal, it is executed in the Ma Yüan style. It is worth noting here that a number of paintings, mostly of Buddhist subjects, which are signed "Hakp'o" (Yi Sang-jwa's penname) and done on dark brownish hemp, are considered forgeries probably made only several decades ago.⁶

As in the preceding century, the Kuo Hsi tradition was still the strongest stylistic force in the first half of the sixteenth century; most of the surviving major landscapes of the period are done in the manner of the Kuo Hsi tradition. In comparison with the previous century, the Kuo Hsi tradition in this period became even more Koreanized. Brush strokes began to be coarser, forms more regulated and mannered, and space between land areas somewhat wider. Although Korean painters of the period absorbed some new elements, mostly minor ones, from China in their works, it was the Korean landscape painting of the preceding century that most influenced them. The compositional scheme of the *Four Seasons* attributed to An Kyŏn *(Figs. 3a-3c)* in which one half of a painting is given more emphasis and weight than the other half, seems to have been most frequently followed by these later landscapists; a major difference is that such painters

often inserted a unit of form between the foreground and background to make their works look more complicated. Along with this branch of tradition in which the asymmetrical composition and monumental design inherited from the Northern Sung landscape tradition were major factors, there was another branch of landscape in which composition was symmetrical and the Kuo Hsi tradition and the Southern Sung academy tradition were almost equally important.

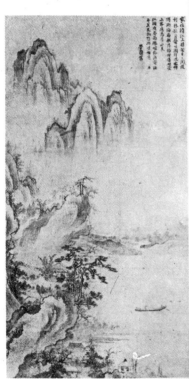 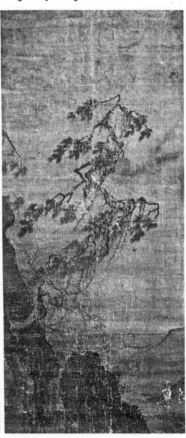

Fig. 1
Yang P'aeng-son (1488-1545):
Secluded Land . 88.5 × 46.8cm.
National Museum of Korea.

Fig. 2
Attributed to Yi Sang-jwa: A *Stroll under the Pine-tree*. 190.3 × 82.1cm.
National Museum of Korea.

Whichever tradition Yi painters adopted, they were always greatly concerned with space, not only in the foreground but also, more significantly, between the different ground planes. A noticeable trait of this period is that painters almost always placed the background farther into the distance than in the preceding century.

Each of the works of the period possesses a distinct style in many of its details. There was greater diversity in style among painters of this period than in the fifteenth century. A manneristic tendency is also unmistakably greater in this period; the painters seem to have tried to be expressive by means of exaggeration, complication, and sometimes distortion of forms.

Around 1550 the Kuo Hsi tradition started to weaken, while the Southern Sung academy tradition temporarily gained strength, only to be superseded by the Ming Che school tradition. Nonetheless, the Kuo Hsi tradition was followed by painters who worked in both the Kuo Hsi and the Che school manners, such as Yi Chŏng-gŭn and Yi Hŭng-hyo (1537-1593) in the second half of the sixteenth century. This style was given a boost by Yi Ching (1581-?) in the first half of the seventeenth century. But it was the Che school tradition which dominated Korean painting for a period of around one hundred and fifty years, between approximately 1550 and 1700.

The two paintings studied here demonstrate the development of the Kuo Hsi tradition in the first half of the sixteenth century and represent the group of paintings with unilateral composition.

The Secluded Land by the Scholar-Painter Yang P'aeng-son

Although Yang P'aeng-son is famous for his scholarship and literary talent, he is also known for his painting.[7] His penname was Hakp'o which was also used by the contemporary academy painter Yi Sang-jwa. Thanks to the biography in his

anthology *Hakp'o-jip* as well as to other records, his dates are known clearly.[8] Yang P'aeng-son came from a scholarly family of a small village called Ssangbong-ri (Village of Twin Peaks) in the Nŭngsŏng-hyŏn District, which is now part of South Chŏlla Province in southwestern Korea. He was born on the nineteenth day of the ninth month in 1488.

After studying under his own father, he became a student of a learned Confucianist-scholar Song Hŭm in 1503 at the age of fifteen. The year before, Song Hŭm had been much impressed by the brilliance of his disciple-to-be. Seven years later, in 1510, Yang passed the *sama* examination and received a *saengwŏn* degree. His lifelong friend Cho Kwang-jo, who made a great impact on him in many ways, passed this examination at the same time. In 1516, Yang successfully passed the *munkwa* examination. Two years later, he passed a special examination which King Chungjong held upon Cho Kwang-jo's advice.

This new special examination system, which admitted a majority of young scholars from Cho's group, was bitterly criticized as unfair by scholar-officials of the other group, and their enmity was one of the main reasons for a political purge of Cho and his followers, known in Korean history as "Kimyo Sahwa" or "Purge of Scholars in the Year of Kimyo (1519)." Cho was sent in exile to Yang's home town. As one of Cho's most faithful friends, Yang led a group of scholar-officials who petitioned the King to pardon Cho, but unfortunately their petition failed. Thereupon, Yang resigned his official post and went home to join his friend. They often discussed scholarly matters there. Their friendship came to an end when Cho was sentenced to death by the court in the winter of 1519.

The next year Yang was completely deprived of his official posts and titles. In 1521 he built a house by a stream in the Village of Twin Peaks, named it "House of Hakp'o," and shut himself off from the world. It was in this house that he lived his long secluded life until his death on the eighteenth day of the eighth month in 1545. Although he was appointed to a

variety of official posts after being pardoned in 1537, he turned them all down until a year before his death, when he accepted the post of magistrate in a district in North Chŏlla Province, not very far from his home. He died in the "House of Hakp'o" in 1545. Despite his relatively well-documented biography, Yang's activities as a painter are not mentioned in the anthology of his writings. This may be because the anthology, compiled three centuries after his death, was based on the manuscripts then extant, most of which were concerned with his official activities.

The only existing landscape by Yang P'aeng-son is at the National Museum of Korea (*Fig. 1*). From the general contents of the two poems signed "Hakp'o" at the upper right corner, the title of the landscape may be said to be *Secluded Land*. The two poems written side by side read as follows:

> *Living in a house built by a clear river,*
> *(I) leave the window open every day.*
> *In the village embraced by the shadow of trees,*
> *The noise of the world is muffled by the water's roar.*
> *Lowering his sail toward lapping water,*
> *A visitor casts anchor.*
> *Fishing boats lift their hooks returning home.*
> *People on the distant plateau have come to view the moun-*
> *tains.*
>
> *The river's vastness keeps away the flying dust,*
> *(And) rushing torrents drown all earthly words.*
> *Do not let fishing boats come and go,*
> *For fear this land becomes connected with the world.*
> *Written (or Painted) by Hakp'o*

An unidentifiable seal, believed to be that of a collector, is placed just below the signature. Although the poem is not recorded in Yang's anthology *Hakp'o-jip*, the calligraphy of the poem and that in the anthology are generally alike, despite the latter being in the running script. Since the poems describe a

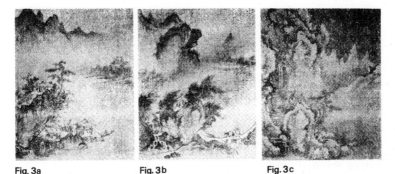

Fig. 3a Fig. 3b Fig. 3c

Fig. 3a Attributed to An Kyŏn. *Late Spring*. 35.2×28.5cm Nat'l Museum of Korea.
Fig. 3b Attributed to An Kyŏn. *Late Summer*.
Fig. 3c Attributed to An Kyŏn. *Late Winter*

reclusive life, it is plausible that the painting was executed during the period between 1521, when Yang built the "House of Hakp'o" for his secluded life, and 1545 when he died in that very house at the age of fifty-seven. Foreground boulders and trees and ink texturing of boulders attest that this painting is a work of the Kuo Hsi tradition.

Yang P'aeng-son's debt to landscapes of the fifteenth century is evident in the general design of *Secluded Land*. As in the *Four Seasons* attributed to An Kyŏn (*Figs. 3a-3c*), a half of the vertical axis is more weighted and emphasized than the other in *Secluded Land*: the right half is arranged vertically while the other is horizontal in design. The big difference between Yang's painting and the *Four Seasons* is that Yang has established a mountain and a hill in the middle ground area.

The hill with a pair of pines and other trees projects obliquely and still dominates the foreground of Yang's sixteenth century painting, as it does in the *Four Seasons* (cf. *Fig. 3a*) of the mid-fifteenth century. Houses are depicted below and behind the hill just as in the *Four Seasons*. Even the vertical tip of one mountain along the left margin is reminiscent of the *Four Seasons* (cf. *Fig. 3c*). However, a pavilion, which stands on top of the foreground hill in the

Four Seasons, is now on an obscure plain beyond the hill in *Secluded Land,* suggesting greater depth. This may be a further development of the same tendency which began to appear in some paintings of the late fifteenth century, such as the *Landscape* attributed to Sŏk Kyŏng (*Fig. 4*) and the *Landscape with a Temple* by Munch'ŏng (*Fig. 5*). Behind the village in the foreground are misty marshlands somewhat reminiscent of those in Southern Sung academy painting,[9] and not far from them a boat approaches the shore horizontally. Most of the foreground at the right hand side is occupied by a vast body of water, as in paintings of the previous century. Atop the hill in the middle ground which diagonally parallels the projecting hill at the lower left hand corner, scholars enjoy a gathering, seated in a circle on the ground and served by two boy attendants. This type of gathering on a plateau lacking a pavilion already began to be depicted in the late fifteenth century. Thus Yang's indebtedness to the 15th century painters and his synthesis of landscape traditions are obvious. However, it should be noted that figures in informal costume of the fifteenth century paintings are transformed by Yang

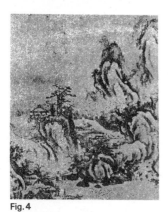

Fig.4

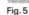

Fig. 5

Fig. 4 Attributed to Sŏk Kyŏng. *Landscape.* 25×22cm. Center for the Study of Korean Arts.

Fig. 5 Munch'ŏng. *Landscape with a Temple.* 31.5×42.7cm. Nat'l Museum of Korea.

into officials wearing formal dress and hats — an indication of the rigid Confucian formality which influenced the scholar-officials of this period.

Isolated and surrounded by thick mist at their bases, the main mountains look as if they were floating in a sea of mist, as seen in the painting by Munch'ŏng (*Fig.* 5). Although the treatment of the surface and configuration of mountains and hills are generally reminiscent of that of the fifteenth century, Yang's mountains are even more conventionalized and simplified, and are treated with drier brush strokes. Unlike mountains in Chinese monumental landscapes, those in *Secluded Land* as well as most Yi landscapes are neither awesomely grandiose nor unapproachably majestic.

In *Secluded Land*, a stream meanders from behind the hill in the middle distance into the river in the foreground, along which space recedes until it disappears into the mist. This stream is remarkably similar to its counterpart in *A Gathering of the Scholars of the Toksŏ-dang*, datable to 1531.[10] And it is also interesting that the mountain in the center of the background, the pair of pines in the middle ground, and the big pines in the foreground are all in the same vertical line. With the extremely logical composition, the landscape has a quality of refinement not usually found in the work of professional painters who lacked a scholar's education.

As the only extant landscape painting of the Kuo Hsi tradition executed by a sixteenth century scholar-painter, *Secluded Land* shows both somewhat conservative adherence to the Korean landscape tradition of the preceding century (which might be referred to as the An Kyŏn tradition) and some remarkable features of the first half of the sixteenth century in the treatment of space, brush work, and certain details. The units of land are separated into repeated promontories and distant peaks in wide areas of mist and water, achieving a balanced asymmetry. The loose contour lines detached from forms and parallel texturing and shading of rocks and mountains are also noticeable features.

The Daigan-ji Screen Painting:
The Eight Views of the Hsiao and Hsiang Rivers

Sung Ti (965-1043) of Northern Sung is traditionally known to have initiated the theme of "The Eight Views of the Hsiao and Hsiang Rivers" although its development may actually have begun before his time.[11] We do not know when the theme was first introduced into Korea, but it became a popular subject among Korean painters and scholars in, at the latest, the twelfth century. King Myŏngjong of the Koryŏ dynasty, who ruled between 1171 and 1197, ordered his scholars to compose poems on this theme and had his favorite painter Yi Kwang-p'il paint scenes of the theme.[12] By this time, paintings of the theme done by or attributed to Sung Ti must have been introduced to Koryŏ scholars and painters. For example, two famous Koryŏ poets, Yi In-ro (1152-1220) and Chin Hwa (who passed the *munkwa* examination in 1200), composed poems on Sung Ti's painting *The Eight Views of the Hsiao and Hsiang Rivers.*[13] The continued popularity of the theme in the later Koryŏ period is seen by the fact that prominent scholars of successive generations such as Yi Kyu-bo (1168-1241) and Yi Che-hyŏn (1287-1367) wrote poems about it.[14]

It is obvious that the theme was still prevalent in the Yi

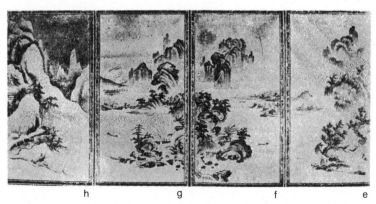

h g f e

Fig. 6 Anonymous. *The Eight Views of the Hsiao and Hsiang Rivers.* 494×99cm.

period. For example, Prince Anp'yŏng (1418-1453) had *The Eight Views of the Hsiao and Hsiang Rivers* painted and poems composed by scholars in 1442 after acquiring a poem written on the theme by Emperor Ning-tsung of Southern Sung.[15] Poems by the Koryŏ poets Yi In-ro and Chin Hwa were also included in the Prince's scroll *The Eight Views of the Hsiao and Hsiang Rivers.* While no painting of the theme is extant from Koryŏ or the fifteenth century Yi dynasty, a number of paintings survive from the sixteenth and seventeenth centuries. In an assimilation of the Hsiao and Hsiang theme, *The Eight Views of Songdo* (the Koryŏ capital) was created sometime in the late Koryŏ period and was passed on to the early Yi.[16] Again, no early painting of *The Eight Views of Songdo* is extant.

In Prince Anp'yŏng's collection were Kuo Hsi paintings such as "Wild Geese Descending to the Shore" and "Evening Snow in the Rivers and Sky" (both of which are titles of *The Eight Views of the Hsiao and Hsiang Rivers*) as well as a complete set of paintings of the theme by a Yüan painter Li Pi.[17] To my limited knowledge, no Chinese source reports Kuo Hsi's having painted the theme, but considering that Kuo was active almost half a century after Sung Ti, his having done so is not inconceivable, at least in chronological terms. Li Pi, who

d c b a

Coll. of Daigan-ji, Itsukushima, Japan.

is totally unknown in China, was apparently very well known among Korean painters of the late Koryŏ and early Yi periods. However, none of his work has survived to the present.

The Eight Views of the Hsiao and Hsiang Rivers, an eightfold screen at Daigan-ji of Itsukushima, Japan, is the earliest surviving Korean painting of the theme *(Figs. 6a-6h)*. A diary written on the back of the screen by the Japanese monk Sonkai (who brought it with him to Japan as a souvenir from Yi dynasty) supplies important material for the study of diplomatic relations between Korea and Japan and provides the terminal date of the painting: 1539.[18] Sonkai, who came to Korea to obtain Buddhist sutra on behalf of Daigan-ji, landed at Pusan on the ninth day of the fifth month, 1539. Two months later, he arrived in Seoul and stayed there for about three months until his departure on the thirteenth day of the ninth month. No information is given concerning his non-official activity in Seoul and his acquisition of the screen-painting.

The screen, which is painted in ink of somewhat bluish tone, is preserved relatively well. The identity of the artist who painted this screen painting is not known. A Japanese scholar has attributed the painting to Yang P'aeng-son (1488-1545) after comparing it with Yang's *Secluded Land (Fig. 1)*.[19] This is not acceptable, although there is no particular reason to doubt that the two paintings are contemporary works. But the general similarity between them in composition, which reflects contemporary developments in design, is overshadowed by differences in details and brush work. They are works by different hands.

The scenes depicted in *The Eight Views of the Hsiao and Hsiang Rivers* are identified from right to left as follows:

(1) "Mountain Village in the Clearing Mist" *(Fig. 6a)*. The middle ground scene in which four tiny bent figures ascend a narrow, elevated path barely revealed by dense mist, is a little reminiscent of its counterpart in "Mountain Village in the Clearing Mist" by Yü-chien.[20] And, since the other

seven panels all have unmistakable attributes or hallmarks for identification, as will be discussed, this panel cannot be any other scene than "Mountain Village in the Clearing Mist."

(2) "Evening Bell from the Misty Temple" *(Fig. 6b).* Tall Temple buildings, as well as an upright pagoda in the gorge of distant mountains and home-coming figures on the bridge in the foreground, prove this panel to be the scene of the "Evening Bell from the Misty Temple."

(3) "Returning Sails off the Distant Coast" *(Fig. 6c).* Small boats in the middle distance approach the mist-veiled village.

(4) "Sunset Glow over the Fishing Village" *(Fig. 6d).* Nets are cast here and there, and the sunset glow illuminates the mists surrounding the distant mountains.

(5) "Night Rain over the Hsiao and Hsiang Rivers" *(Fig. 6e).*

(6) "Autumn Moon over Lake Tung-t'ing" *(Fig. 6f).*
The round moon hangs high in the sky and a moon-viewing party is seen in the middle distance.

(7) "Wild Geese Descending to the Shore" *(Fig. 6g).*

(8) "Evening Snow in the Rivers and Sky" *(Fig. 6h).*

The Eight Views of the Hsiao and Hsiang Rivers fundamentally belongs to the same lineage as *Secluded Land* by Yang P'aeng-son, the origin of which is traced back to the *Four Seasons* attributed to An Kyŏn *(Figs. 3a-3c).* The screen painting differs from the *Four Seasons* in that it is more crowded, detailed, and mannered, and yet more spacious. A remarkable difference is also detected in the brush work of the screen painting: brush strokes, which began to be considerably individualized in probable late fifteenth century works *(Figs. 4-5),* become even more "individually distinct" and harsher in *The Eight Views of the Hsiao and Hsiang Rivers.* And it should also be pointed out that similar types of designs and motifs are repeated more often in the screen painting than in any preceding work, which would seem to indicate that the

painter was more traditional than innovative.

However, each panel ought to be studied briefly in order to understand the characteristic features of the period that the painter embodied in this screen painting.

In "Mountain Village in the Clearing Mist" (*Fig. 6a*), such horizontal elements as the oddly shaped promontory in the foreground, the low dome-shaped mountain with a rather wide path, the long wall in the middle distance and the mist-veiled rooftops behind it, gradually rise to higher levels and recede step by step at the same time, until the viewer's eyes finally reach the tallest peak of the main mountain. An obliquely jutting mountain at the middle height of the right edge not only prevents the long, horizontal wall from dividing the entire painting into two parts, upper and lower, but also gives a strong, diagonal accent to the painting, tending to bring the slanting ranges of the main mountain in the distance close to the viewer. The way the main mountain floats in the distant, vast sea of mist is very reminiscent of the contemporary work *Secluded Land* (*Fig. 1*), and is a trait which began to develop in the *Four Seasons* (*Figs. 3a-3c*) and was accelerated by Munch'ŏng (*Fig. 5*).

The low dome-shaped mountain, on top of which the pair of pine trees grow, is textured in much the same way as the mountains and boulders in *Landscape* attributed to Sŏk Kyŏng (*Fig. 4*). Contour lines of this mountain as well as of the others are exceedingly sinuous. And it is noteworthy that a favorite motif in the 15th century landscape, a hill surmounted by a pavilion and some trees in the foreground, does not appear in this panel. It appears in other panels of the screen with variations (*Figs. 6d,6g,6h*), but its size and role are no longer as prominent and significant as in the fifteenth century works.

Although mountains in "Evening Bell from the Misty Temple" (*Fig. 6b*) are skillfully interwoven together by the zigzag movement along the ranges, they gradually recede into the distance, leading the viewer's eyes to the focusing point at the tip of the pagoda in the gorge of distant mountains. The

bridge in the foreground and the marshland in the middle distance give the stability of horizontal accents to the painting. Except for the intentionally trembled contour lines and the treatment of surface with linear strokes, the tilted mountain slope at the lower left corner is reminiscent of its counterpart in the Yüan Chinese painting *Playing a Ch'in under the Pine trees* by Chu Te-jun.[21] A shell-shaped rock-formation or hill surmounted by the two pine trees in the middle of this mountain slope stands obliquely and precariously on an absolutely uncertain base. Although the way this rock-formation is represented reminds us of An Kyŏn technique as seen in the left half of the *Dream Journey*,[22] the motif itself, *i.e.* the independent rock-formation surmounted by two pine trees, was apparently picked up from Chinese-painting.[23] This is a newly-adopted element. Most of the space in the right half of this panel is occupied by water. When this second panel is joined with the first panel, we see a wider body of water which is about to be encircled by the mountains of the two panels; the same feature recurs in the following pairs of panels (*Fig. 6*).

Although reversed, "Returning Sails off a Distant Coast" (*Fig. 6c*) is basically the same as the second panel in general composition. However, a sense of depth and spatial recession is more successfully achieved in this panel than in the second. Three returning boats beyond horizontal marshlands in the middle distance are arranged one after the other in such a way that a diagonal recession is achieved, creating an effect of profound depth. The seemingly scattered elements are rather successfully related to each other by the echoing of convoluted rock and mountain forms. And the tortuous peaks of the distant mountains to the right are very reminiscent of those in "Late Summer" of the *Four Seasons* attributed to An Kyŏn (*Fig. 3b*), and are even more distorted in form.

Different from all other panels of the screen, "Sunset Glow over the Fishing Village" (*Fig. 6d*) has three clearly defined "U-" or "V-shaped" grounds, which recede into depth one

after the other. A low hill behind a mountain slope at the lower left hand corner curves toward the middle ground, forming a rough "U" shape, and leads the viewer's eye to the middle ground and then to the mountains in the background. This characteristic connective device, which probably began to develop in the mid-fifteenth century, is exaggerated and repeated with variations in this screen (*cf. Figs. 6b, 6f*). Another fantastic feature is the giant, diamond-shaped plateau, which is reached by a long, steep path. The sunset glow is best illustrated in the distant main mountains where peculiar hook-like patterns are employed to depict light effects on the piled-up clouds below. The formation of the illuminated clouds around the major mountains is "V-shaped", which emphasizes the downward thrust of the bottomless peaks and counters the upward "U-shaped" movements in the fore- and middle grounds. These somewhat awkward "U-shaped" elements are slightly eased by some horizontal promontories in the middle and far distance.

In "Night Rain over the Hsiao and Hsiang Rivers" (*Fig. 6e*), everything is blown and shaken by a violent rainstorm, even the waterfall of uncertain origin in the mountains of the middle ground. Mountains and hills, bent in the direction of the rainstorm, struggle to maintain themselves against its fierce thrust. Everything is wet. In the right half of the vertical axis, three groups of mountains stand on three different grounds. They recede into depth one after the other, and at the same time pile up one above the other to form a dominant verticality which is hardly balanced by the low horizontal mountain in the center of the left side, done in pale ink with foliage dotting to suggest its location in the far distance. The violence of the rainstorm is accentuated by oblique columns of ink washes in the sky, which get darker in the distance and contrast with untouched white parts between columns.

In "Autumn Moon over Lake Tung-t'ing" (*Fig. 6f*), the curved mountain slope at the lower left corner draws an inclined "U" movement and leads the viewer's eye to another

similar movement across the bridge and then to the groundplane at the middle height of the right edge, in a way similar to the fourth panel (*Fig. 6d*). The diagonal recession of the shores of the middle distance at the right edge suggests a remarkable depth. A long boat accents this recession. Far in background, emerging from a sea of mist, the main mountains are more patterned than the other mountains in the screen and are somewhat similar to those in *Secluded Land* by Yang P'aeng-son (*cf. Fig. 1*).

The *baroque,* An Kyŏn type of mountains behind the bridge, inclined toward the viewer, are precariously situated—they could collapse at any moment from the slightest quake. This crisis is doubled by the weight of a multi-storied pavilion supported by rows of columns, located on the most dangerous overhang exactly above some thatched houses. We experience the same kind of thrill in An Kyŏn's *Dream Journey.* At the right hand side of the bridge is a hill which resembles an enlarged oyster shell—a motif not found in earlier works.

Deprived of their luxuriant foliage, mountains and hills in "Wild Geese Descending to the Shore" (*Fig. 6g*) look rather stark. They are treated with darker and coarser brush strokes than in the other panels, which would seem to indicate an attempt to represent the harsh atmosphere of a late, chilly autumn. An impressive element in the panel is the depiction of wild geese in the background. Some rather peculiar geese flop about marshlands done in ink wash, while others nearby look like snake-heads or bean sprouts—a feature unlikely to be seen in Chinese or Japanese painting.

As opposed to the other panels in which the vast, open space is one of the most characteristic features, everything in "Evening Snow in the Rivers and Sky" (*Fig. 6h*) appears closer to the viewer. The major mountains, for example, are no longer moved far into the distance. Instead, they jut out toward the viewer and are linked to the foreground by the mountain with the path in the middle distance. Most of the

mountains are arranged to form intersecting diagonal movements. A village behind the long, diagonal slope is surrounded by a wooden fence and enclosed by silhouetted mountains, which recede one after the other into the distance. The encirclement of a background village by means of silhouetted mountains is a tradition of Korean wintry landscapes, first seen in "Late Winter" of the *Four Seasons* attributed to An Kyŏn (*Fig. 3c*). The major difference between the two paintings is that while the silhouetted mountains in "Late Winter" are lined up in the same row like a screen, those in "Evening Snow in the Rivers and Sky" recede into the distance one by one. As a whole, the composition of this panel is different from that of the other panels. Interestingly, however, the style of this last panel is much closer to the Ming Chinese painting *Yüan An Lying on the Snow* [24] (which is conventionally attributed to the Yüan painter Yen Hui), and is a good contrast to other panels which show Koreanized adaptations of Yüan and pre-Yüan origins.

As we have seen, the anonymous artist of this screen learned much from Korean painting of the previous century and some from Yüan and Ming Chinese painting as well, but he also represented many characteristic features of his period. Along with *Secluded Land* by Yang P'aeng-son (*Fig. 1*), this screen painting belongs to the same tradition as the *Four Seasons* attributed to An Kyŏn (*Figs. 3a-3c*). The painter of the screen tried hard to be expressive by depicting exaggerated forms, and repeatedly rendered the same type of composition, which inevitably resulted in a kind of mannerism. Nonetheless, in brush technique and connective devices, a certain amount of individuality appears. By and large, the screen painting is a good example of what changes the Kuo Hsi tradition underwent in Yi dynasty in the first half of the 16th century.

NOTES

1. They are the scholar-painters Yang P'aeng-son (1488–1545), his friend Sin Cham (1491–1554), Madame Sin Saimdang (1504–1551), Kim Che (?), An Ch'an (?–1519), Ch'oe Su-sŏng (1487–1545), Chŏng Ryŏm (1506–1549), and the academy painter Yi Sang-jwa (?).

2. For a study of the mid-fifteenth century master An Kyŏn and his painting style, see An Hwi-Jun, "Korean Landscape Painting in the Early Yi Period: The Kuo Hsi Tradition," (Ph.D. dissertation, Harvard University, 1974), pp. 84–143; "An Kyŏn and His Painting, *A Dream Journey to the Peach Blossom Land*" (in Korean), *The Chin-tan Hakpo* Vol. 38 (October, 1974), pp. 49–73; "The *Red Cliff* Conventionally Attributed to An Kyŏn" (in Korean), *Hongik Misul* No. 3 (November, 1974), pp. 77–86.

3. Yu Pog-yŏl, *Pageant of Korean Painting* (in Korean) (Seoul: Mun'gyowŏn, 1969), Pl. 39.

4. Two landscapes have been falsely attributed to Madame Sin Saimdang by Yu Pog-yŏl, *ibid.*, Pls. 55, 56. They are executed in the later literati style and their actual dates are probably much later than Madame Sin Saimdang's time of activity, probably by a few centuries.

5. *Ibid.*, Pls. 62–65.

6. This type of painting exists in large numbers both in Korea and Japan. Most of them are apparently by the same hand and done on the same material. They are usually very large.

7. O Se-ch'ang, *Kŭnyŏk Sŏhwa Ching* "Literary Evidences of Korean Calligraphy and Painting" (Seoul: Hagmungak, 1970), p. 74.

8. Yang P'aeng-son, *Hakp'o-jip* (1914 edition), *Chuan* 4, and Chŏng Wŏn-yong, *Kyŏngsan-jip* (1895), *ch.* 19, pp. 19a–27a.

9. The marshlands and the solidly logical composition are somewhat similar to their counterparts in *Pavilions in the Mountains* by Hsiao Chao. See *Three Hundred Masterpieces of Chinese Painting in the Palace Museum*, Vol. III, Pl. 103. This idea was brought to my attention by Dr. Susan Bush of the University of Massachusetts.

10. An Hwi-Jun, "Korean Landscape Painting ," pp. 194–208, Pls. 15a–15b.

11. Shimada Shūjirō, "Sung Ti and 'The Eight Views of the Hsiao and Hsiang Rivers' " (in Japanese), *Nanga Kansho* (April, 1941), p. 13.

12. Chŏng In-ji and others, comp., *Koryŏ-sa, ch.* 122 (Biography *ch.* 35), p. 4a.

13. Sŏ Kŏ-jŏng and others, comp., *Tongmunsŏn* "Selected Writings of Korea," Reprint (3 vols.; Seoul: Kyŏng-hŭi Ch'ulp'an-sa, 1966), Vol. I, pp. 63–64, 231–322, 248; Chin Hwa, *Maeho Sŏnsaeng Yugo* "Ex-

tant Writings by Maeho," *ch.* 1. pp. 19a–21b and p. 13b.

14. Yi Che-hyŏn, *Ikchae Nan'go, ch.* 3, pp. 8b–9b and *ch.* 10, pp. 7a–10a.
15. Sin Suk-chu, *Pohanjae-jip, ch.* 10, pp. 1a–1b; *Yuk Sŏnsaeng Yugo,* Vol. I(Extant Writings of Pak P'aeng-nyŏn), pp. 8a–9a; Sŏ Kŏ-jŏng and others, comp., *Tongmunsŏn,* Vol. I, pp. 270–271.
16. For example, Yi Che-hyŏn composed poems on the theme. See *Ikchae Nan'go, ch.* 10, pp. 10a–13b; Sŏ Kŏ-jŏng and others, comp., *Tongmunsŏn,* Vol. I, pp. 247–248; *Sejong Sillok, ch.* 148 (Geography of Kyŏnggi Province), p. 3b. "The Eight Views of Songdo" consisted of "Monk Visiting the Purple Village," "Seeing off Guests in the Blue Suburb," "Misty Rain in the Northern Mountains," "Snowstorm on the Western River," "Clearing Clouds in the White Mountains," "Evening Glow over the Yellow Bridge," "Rocky Cliffs of Changdan," and "Waterfalls of Pagyŏn."
17. Sin Suk-chu, *op. cit., ch.* 14, pp. 3a–4a.
18. For a complete reading of the diary, see *Bijutsu Kenkyū* No. 28 (April, 1934), pp. 179–181. Sonkai's diary and the diplomatic relationship between Korea and Japan at that time have been discussed by Nakamura Eikyō, "Sonkai's Trip to Yi dynasty" (in Japanese), *Nissen Kankei-shi no Kenkyū* (Studies on the History of Japan-Korea Relationship) (3 vols.; Tokyo: Yoshikawa Kobun-kan, 1955–1960), Vol. III, pp. 729–748. The general aspects of the screen painting were discussed by Takada Tsuneo, "The Screen Painting with Sonkai's Diary in the Daigan-ji Collection" (in Japanese), *Bukkyō Geijutsu* No. 52 (November, 1963), pp. 127–130.
19. Sekino Tei, *Chōsen Bijutsu-shi* (History of Korean Art) Seoul, 1932, pp. 257–258.
20. Tokyo National Museum, ed., *Sōgen no Kaiga* (Chinese Painting of the Sung and Yüan Dynasties) (Tokyo: Benri-do, 1952), Pl. 123.
21. For the picture, see Osvald Sirén, *Chinese Painting: Leading Masters and Principles* (7 vols., New York: The Ronald Press Company; London: Lund Humphries, 1956), Vol. VI, Pl. 92.
22. An Hwi-Jun, "An Kyŏn and His Painting, *A Dream Journey to the Peach Blossom Land,*" pp. 66–70 and Figs. 1–1b.
23. Sherman E. Lee and Wai-kam Ho, *Chinese Art under the Mongols: The Yüan Dynasty (1279–1368)* (The Cleveland Museum of Art, 1968), Fig, in the entry 216.
24. For the picture, see *Ku-kung shu-hua chi,* Vol. IV.

Yi Dynasty Scholar Painting

SŎK DO-RYUN

The foremost feature characterizing the social and ethical reformation which took place in the early days of the Yi dynasty (1392-1910) was the retreat of Buddhism and the emergence of Confucianism. Following the power change that gave birth to the new dynasty, Buddhism was rejected in favor of Confucianism as the state religion. Thus a mood of reform became prevalent in all aspects of social life—in education, politics, economic activities, customs, etc. The social metamorphosis was conceived by the reformative plans formulated by a group of radical progressives who controlled the new regime.

The seeds of Confucian upsurgence had already been sown during the Koryŏ period (918-1392) when such prominent Confucian scholars as An Yu and Chŏng Mong-ju advocated the reform of social ethics after witnessing the many evil influences a decadent Buddhism exerted on Koryŏ society. After founding the Yi dynasty, King T'aejo (1392-98) and his courtiers attempted to eliminate all the social evils the new regime had inherited from the preceding dynasty by initiating a sweeping reform movement. The eradication of all the Buddhist traditions and conventions which had been part of life itself for the Korean people for many centuries could not be realized in a short period of time, for it was a great historical task challenged by internal as well as external factors which were as formidable as the former was colossal.

King T'aejo founded the new dynasty by forcibly usurping

the throne of the Koryŏ king. Three years after his coronation he moved the capital of Korea from Kaesŏng to Seoul following his success in subjugating the minds of the people and entering into friendly relations with China. Fond of Buddhism though he was, the founder king could not alone divert the trend of the times as confusion reigned over the nation in the wake of the birth of the new dynasty.

His son, King T'aejong, the third monarch, oppressed Buddhism and encouraged the development of Confucianism to the maximum. By establishing a typefoundry and promoting the printing of Confucian literature, he did his utmost to propagate Confucianism. King Sejong, the fourth monarch, had many notable achievements to his credit, including the invention of *Han'gŭl* (the Korean alphabet) and the development of industry and trade. Appointing scholars of great endowment and high reputation to prominent government positions, the monarch had them study astronomy and the calendar for utilization in the daily life of the people and readjust musical instruments and scores so that the Sung dynasty music could be adopted in its orthodox form.

As all new institutions concerning culture, education, art and politics took firm roots in Yi dynasty, the seventh monarch, King Sejo, further elevated the nation's cultural standards by publishing the *Kyŏngguk Taejŏn* (The Great Law for Governing the Nation) in 1471. He also established a government agency charged with publishing Buddhist literature and a number of Buddhist scriptures were printed in both *Han'gŭl* and Chinese characters. The ninth monarch, King Sŏngjong, himself well versed in Neo-Confucianism, contributed much to further promoting Chinese learning. By his royal command such outstanding publications as *Kukcho Orye* (Five Ceremonials of the Yi Dynasty), *Tongguk Yŏji Sŭngnam*, a geographical study of Korea, and *Tongmunsŏn*, an anthology of verse and prose by Yi dynasty masters were edited and published. Thus all regulations and institutions were readjusted and a golden era in cultural prosperity emerged

with popular living attaining constant improvement. All the people enjoyed a secure and peaceful life.

The peaceful and contented people were dealt a fatal blow when Japan launched an invasion (1592-98). Had it not been for this conflict, Yi dynasty could have achieved unprecedented cultural prosperity during the reign of King Sŏnjo, the 13th monarch. The Japanese invasion, lasting for eight years until the allied forces of Korea and Ming China succeeded in expelling the invaders, virtually devastated the entire country. The scholar painting of the Yi period, as dealt with in this article, has its origin in the golden era which preceded the Japanese invasion when the life of the Korean people was filled with vigor and hope.

Neo-Confucianism, which came to life and was developed during the Sung period (960-1279) and which acquired the name of Sung Learning, was aimed above all else at self-discipline, wise government and the enlightenment of the people. It was for this reason that Confucianists concentrated their concern on statecraft and statesmanship and their ultimate goal was to put into practice what they believed to be the supreme ideal. This task required that they possess ability in many different fields — not only in politics and economy but also in education, history, geography, astronomy and arts.

Those scholars who believed in Confucianism, as their philosophy dictated, were resolved to reproduce the wise government of Yao and Shun, two legendary kings believed to have ruled ancient China. This inspired Confucian scholars to positive participation in politics whenever the opportunity presented itself. In fact, Confucian scholars eagerly sought such opportunities. They belonged to the select few, as well as to the ruling class, and it was their desire to be called *kunja* (a gentleman-at-his-best) who was considered the most ideal man in countries coming under the sphere of Chinese culture.

At first Confucian scholars constituted a small portion of the population. As time passed, however, they grew in number and many different schools shot up within Neo-Confucianist circles that upheld the same philosophy. These schools functioned as political factions when scholars took part in statecraft. The emergence of academic schools intensified political wrangling. Once defeated in a power struggle, scholars had to retreat from the political scene which bespeaks schism within the ruling class itself. Those deprived of the opportunity for political participation were called *hallyang* (the leisurely good) who idled away their time doing nothing worthwhile. Those allowed to display their political ability were very few in number and so most scholars failed to obtain a government position and joined the discontented and despair-ridden masses. To make matters worse, they belonged to the non-productive class which, nevertheless, reigned over the populace as an oppressor.

Friction and suspicion between the *hallyang* (those belonging to the opposition camp or those who had retired from politics) and the *sŏllyang* (the selected good or those belonging to the ruling camp or who were in active government service) became worse as the years passed. They opposed each other merely for the sake of opposition thus sowing the seeds of internecine feuding in which contenders fought each other for no definite political ideology. Factionalism which spread among Yi dynasty Confucianists created a tense social atmosphere and Yi society lacked a strong ideology or consciousness of the tasks of overcoming the worsening situation. The nation plunged into utter fatigue following the Japanese invasion. A certain strong and fresh ethical movement or renovation of national consciousness was the prerequisite for reconstruction but Yi society again lacked both.

To the Confucianists the scholar painting was a substitute for their loss of religion or a hobby from which they sought temporary comfort. The scholar painting can hardly be

regarded as having grown into a unique genre in the art of painting nor is it considered effective as a religious substitute for the Confucianists. It was treated as secondary among the conditions required of gentlemen of culture, that is to say, it was regarded as inferior to knowledge of the Chinese classics and poetry.

The Yi dynasty scholar painting has its origin in China, where for nearly 15 centuries from the Sui (518-618) to Ch'ing (1616-1912) dynasties it was considered one of the essentials in which all cultured gentlemen should be well versed while serving as one of criteria on which government officials were selected.

In the Silla and Koryŏ periods all formative arts grew with Buddhism. In the Yi dynasty, however, they were nourished by Confucianism. In other words, the change in dynasties released formative arts from religious service. This change demanded that the arts alter their aspects completely, that is, transform themselves from tools in the service of the Buddhist faith and modes of living. This is the internal situation in which the dynasty's formative arts developed.

Confucianism places emphasis on the virtue of frugality. Therefore, it does not make heavy demands that arts serve for ceremonials or evoke feelings of grandeur. This essence of Confucianism made it possible for the formative arts to free themselves from subjugation to purposes other than their original mission. Such great masterpieces the Yi dynasty has bequeathed to posterity as wood works, ceramic pieces and paintings were all products of the peculiar and unique characteristics of the times. The dynasty's handicraft items secured their basis in the course of serving the demand arising from the daily life of the people. If there had not been interactions between arts and views on wooden handicrafts, ceramic articles, stationery or paintings held by scholars who

possessed the power of ruling the dynasty society, it would have been impossible for the dynasty to develop its arts to such a level. The influence scholars exerted on painting was definite and decisive. This is mainly because they exercised almost absolute power over their society.

The dynasty scholars, whether they were the "selected good" or the "leisurely good," were, with no exception, fond of calligraphy and painting. (The two are one in the case of scholar painting.) Especially theirs was a time when Korea was subject to constant influence from the new renaissance movement raging in the Ming empire on the Chinese continent. The tendency to enjoy calligraphy and painting was further promoted by the fact that the government, for centuries, had appointed ranking public officials in accordance with their literary ability. In addition to this, the dynasty scholars were deprived of a religion after Buddhism was expelled from the position of the state religion and, as a result, they sought a substitute that could fill the vacuum. This state of mind, as already explained, led them to cherish calligraphy and painting so that they could comfort themselves.

Scholar painting, generally speaking, was given birth by the spiritualism which pervades Oriental formative arts. Referring to Wang Wei (669-759), a great painter and a deputy prime minister of the T'ang empire, Su Tung-p'o (1036-1101), a literary genius of the Sung period, once remarked: "In his poetry there is a painting and in his painting there is a poem." Tung Ch'i-ch'ang (1551-1636), a great literary figure and an authority on the methodology of historical researches in the Ming dynasty, once explained, "Scholar painting originates in Wang Wei...."

However, scholar painting did not form its definite characteristics in the T'ang period (618-907). It may suffice to

say that Wang Wei symbolized the spiritualism that underlies the general tone of Oriental painting. It was only during the 13th and 14th centuries—from the latter part of the Southern Sung period (1127-1279) through to the Yüan period (1279-1368)—that scholar painting started to acquire a clear character. A conspicuously definite form was given to it during the Ming (1368-1644) and Ch'ing (1616-1912) periods.

In the Sung empire, an academy of painting was established under the auspices of the royal court as a means of providing state encouragement for artists. All from the emperor down to ranking officials busied themselves with painting and their enthusiasm entailed the emergence of a number of prominent painters who competed with each other for supremacy and lifted Chinese painting to the highest level ever attained by artists of any other period throughout the history of Oriental painting. Their matured techniques reached the superlative in perfection. Their style came to be known as "academism" which formed a pattern and tradition for Oriental painting in later periods. Works of academism naturally exerted far-reaching influence on paintings executed thence-forth. When viewed from the angle of scholar painting, however, "academistic" paintings can be regarded as government-patronized and as placing emphasis on merely technical skills.

As explained above, there was a revolt in the 13th and 14th centuries against the government-patronized academism which gave the first consideration to technical matters. This revolt was the embryo of scholar painting. Carried on mainly by scholars who did not hold government positions, the movement finally reaped fruit during the Ming and Ch'ing periods. In other words, scholar painting made its start as an opposition to the "academistic" pattern. It was after the reign of King Sejong (1419-1450) that the movement as a revolt against academism was introduced to Korea.

The rise of scholar painting in Korea was directly influenced by the introduction of a theory advocated by Tung Ch'i-ch'ang praising the southern style and denouncing the northern style.

His view, assailing academism, served as theoretical background for the rise of the "Southern Painting" in China. The decisive factor for the emergence of the Southern School in China was a free movement arising from the non-bureaucratic temperament of scholars who shunned government positions. In Yi society scholar painting was inherited and developed by scholars in the ruling class who despised professional painters while regarding their occupation as lowly.

Scholar-gentlemen, who considered it a vulgar skill to faithfully copy an object on the canvas and for this reason despised professional painters, were wrapped up in their Indian-ink painting regarding it as a sacred form of art. The Yi dynasty painting, which managed to free itself from all the yokes of Buddhism that had bound the arts since the Silla period, now gave birth to a new form of painting—scholar painting—which aimed at emancipating itself from shackles of mechanism. Thus a new horizon started to unfold for the Yi dynasty painting. Two antagonistic elements—the art of professional painters and the painting of scholars as a hobby, the mechanical nature of the former and spiritualism of scholar painters—ran parallel with each other without knowing reconciliation and indicating the social disparity which discriminated the two groups of people from each other.

Sŏ Kŏ-jŏng (1420-1488) once remarked that both the new style of scholar painting and the Southern School painting were first introduced to Korea through the Yüan empire during the reign of King Ch'ungsŏn (1310-1313) of Koryŏ. King Ch'ungsŏn, when he was taken to the Yüan court as a hostage while he was a prince, had an opportunity to make friends with Chao Meng-fu (1254-1322), a noted Confucian scholar, painter and calligrapher, whose paintings and calligraphic

works, together with other Chinese articles, the Koryŏ prince brought back home, thereby stimulating a new style which later came to be called scholar painting, so related Sŏ.

The newly introduced scholar painting infused fresh air into the declining Koryŏ society where a campaign was in progress to eliminate the evils emanating from Buddhism and in its place Confucianism was making gradual but deep inroads. It can be easily imagined how enthusiastically scholar painting was welcomed by the literati mainly because it was not tainted by Buddhism.

In China, however, quite unlike the development which took place in Yi dynasty, scholar painting entered into inseparable relations with Buddhism. Southern China, that is, the region south of the Yangtze River, is in sharp contrast to northern China in terms of both geographical features and human temperament. The dissimilarity is ascribable for the differences existing between the two regions in philosophy, way of life and historical achievements. It is for this reason that they are often compared to each other now, as in the past, when Chinese culture is discussed.

It is intensely cold in winter in northern China whose landscape is dominated by steep and rugged mountains. These natural features have made the northern inhabitants a simple and serious-minded people. Northern painting, which grew up under these circumstances, is sharp, well-regulated and stiff, does not permit false decoration and lives up to formalism. On the contrary, southern China is blessed with a mild climate, fertile land and many rivers and lakes. Its landscape, permitting a far and wide perspective, generates affectionate sentiments and promotes poetic feelings.

Ancient Chinese culture, which was nourished mainly in the region north of the Yangtze River, is characteristic of a rigorous and stern ethics. To protect itself from social chaos and foreign incursions, the Sung dynasty moved its capital from Taifeng to Linan (presently Hang-chou) south of the Yangtze River thus opening the Southern Sung dynasty. The

new capital, bordering on the picturesque West Lake, presents truly beautiful scenery as if reminding one of a southern painting. That the new capital was situated in so scenic a spot bears epoch-making significance for the ground was thus leveled for the appearance of the poetic and unrestricted style called the Southern Painting.

If it can be said that the T'ang period witnessed the realization of grand and magnificent institutions and systems bringing to fruition the Chinese civilization which originated in the ancient states of Yin and Chou (1122? B.C.-256 A.D.), then the Sung period can be termed as that when culture, especially the formative arts, was elevated to spiritual heights through the intermediation of the most straightforward sensation. During the Ming dynasty era, which succeeded the Sung era, the artdom was animated by the activities of a number of noted masters, among whom Tung Ch'i-ch'ang, with his achievements in the methodology of historical

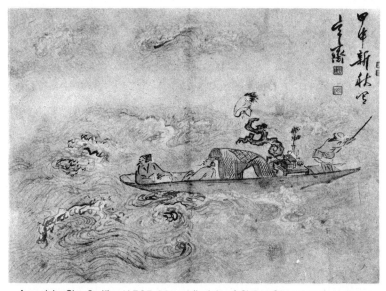

A work by Sim Sa-jŏng (1707-69), a disciple of Chŏng Sŏn whose paintings are reproduced in the cover. Sim's pseudonym was Hyŏnjae and he is called one of *Three Jaes* together with Chŏng (Kyŏmjae) and Kim Dŭk-shin (Kŭngjae).

researches, laid a bridge linking the Ming dynasty with the modern age.

Another explanation worth making here in this connection is that just as there were two sects in Chinese Zen Buddhism — the northern and southern sects which came into being in the T'ang period — there were two schools in painting and among painters. The northern and southern schools of painters also had their origin in the T'ang period. Classifying painters into the two schools was based on style and not on birthplace. Wang Wei, who is generally considered the originator of scholar painting, was born in northern China, which clearly demonstrates again that the northern and southern schools were divided not according to the place of birth of a painter. The northern school, based on academism, mechanism and formalism, encompassed academicians of both the Northern and Southern Sung dynasties. Painters who opposed academism belonged to the southern school. As already explained, Zen Buddhism played some role in developing scholar painting in China, but in its Korean counterpart Zen Buddhism was spoiled.

It took the Chinese six to seven hundred years to accept and assimilate Buddhism due to clashes between that alien religion and their unique national consciousness. The Chinese finally succeeded in reflecting their national character in Buddhism and developed two sects — Tientai and Zen — in the most unique way. In Korea, however, such strong self-consciousness did not exist when the Korean people accepted the Indian religion, except for a limited number of scholars with a sound philosophical background who clarified the interactions between Buddhism and indigenous elements.

Confucian followers who formed the nucleus of the reformists who took an active part in establishing the new Yi dynasty cited, without exception, the evils of Buddhism as the

first among the vices inherited from the previous dynasty. With this conviction they were firmly resolved to eradicate Buddhism in one day. Constant efforts in this line reaped some results, but Buddhism had lived in the language, thoughts, actions and judgments of the Korean people for so long and had been the state religion for nearly 1,000 years since the days of the Silla dynasty. Both Yi Saek (1328-96) and Chŏng Mong-ju (1337-92), despite the fact that they were fond of reciting the Buddhist scriptures at home, embarked on social reform by upholding Confucian philosophy but without renouncing their Buddhist faith.

Confucianism, as it is mainly concerned with guiding man's conduct in his secular life, is hardly a substitute for religion. It is not the purpose of Confucianism to harmonize man's worldly passions, the discords innate to him, and his self-contradictory nature. When extreme chaos crept into Korean society in the wake of repeated political feuding, scholars chose to retire from social participation and to seek spiritual chains with which to bind their wandering minds. However, the early period of the Yi dynasty saw no inkling of such an emergency. The scholars of the initial period simply poured their exceptionally ardent passions into scholar painting as an outlet for their mental burdens. At this juncture it may be easily understood that the motive power behind the Yi dynasty scholar painting was a consciousness deprived of religious faith. In other words, Buddhist consciousness occupied a position in scholar painting and matured in disguise.

As Confucianism was concerned with, among anything else, statesmanship and the enlightenment of the people, Confucianists concentrated their attention on politics. In other words, they were all politically-minded even if all were not politicians. It was an unwritten law binding scholars that they should not take off their socks or robe no matter how humid and hot the weather might be nor sit close by a brazier no matter how cold their room might be, nor were they allowed to visit their wives' chambers except at regular intervals. Even

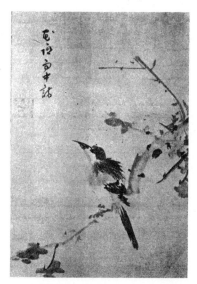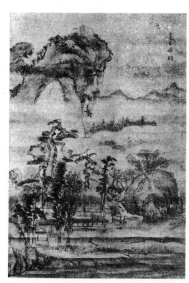

At left is a work by an anonymous painter. The work at right was executed by Ch'oe Puk, another noted painter of the Yi dynasty who took a pilgrimage to every corner of the country for landscape sketches.

when they retired from public life, they should lead a simple life observing every Confucian moral. No matter how destitute they might be, their social position as nobles prohibited them from pursuing any occupation for a livelihood except when they found one suitable to their status. Regulated under such circumstances, they had to enjoy the rest of their life in companionship with poetry, calligraphy or painting.

The literati tried to find a spiritual haven in scholar painting especially when partisan strife grew intense in the middle part of the dynasty era on and even very influential politicians were never immune from execution or exile for involvement in scholar purges. Man's prosperity and decline seemed to them only transitory and vain. The brilliant academic achievements of such prominent scholars as Chŏng Yak-yong (1762-1836), a towering figure in the Real Learning School, and Kim Chŏng-hŭi (1786-1857), the most celebrated calligrapher of Korea, were mainly products of their life in exile. It may not be too much to

say that such political purges resulted in the development and promotion of scholar painting as well as in the shaping of its peculiar characteristics.

Although literary men of the dynasty showed an exceptionally passionate attitude toward painting, they, on the other hand, looked down on painting as a profession. They despised those officials engaged in the painting profession at the government demand. In addition, they were prisoners of the same prejudice holding that their own hobby of painting also belonged to the realm of a vulgar skill. Even such an eminent scholar-politician as Chŏng Nin-ji (1396-1478) remarked that to achieve fame in the arts was shameful for a *kunja*. Kang Hŭi-an (1419-1504), another prominent scholar and a master of painting who developed his own unique style, said that as calligraphy and painting were lowly skills, it would be a shame if one's works were to be seen by posterity. Such a conviction was responsible for the spread of a biased view regarding the arts that a scholar well versed in the arts is to be held in contempt.

The gentlemen of the dynasty who cherished scholar painting grew extremely worried lest their art be mistaken for the "vulgar" skill of professional painters despite the fact that they pursued painting as a hobby. Excessive fastidiousness in this regard led them to oppose even the royal mandate. Cho Yong-u (1685-1759) rejected King Sukjong's request to draw his portrait. After repeated refusals, Cho was forcibly taken into the king's presence, but he continued to reject the royal request on the ground that his conscience as a scholar did not permit him to draw a picture which would defame him. He was strictly punished.

An analysis of their psychology reveals that they firmly believed their idea of painting was not only superior to, but also quite different from, that held by professional painters.

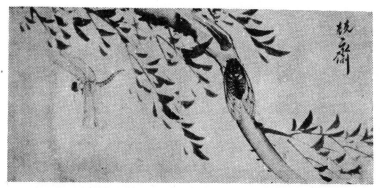

A work by Kim Dūk-shin (1754-1822), alias Kūngjae, who was
excellent especially in minute painting.

No matter by whom they were executed, by scholars or
professional painters, paintings themselves are alike and admit
no discernment, whether they concern landscapes, *Sagunja*
(four plants symbolizing the dignity of gentlemen—plum,
orchid, chrysanthemum and bamboo), portraits, birds and
insects, fish and shell-fish, or still life. Rejecting this, scholars
insisted that their paintings were based on noble ideas whereas
the painters employed by the government office of painting
who followed academism were vulgar. However, we cannot
find any logical or material basis for distinguishing between
the paintings of scholars and those executed by government
painters.

Kang Hūi-maeng (1424-1483) most eloquently represented
the view commonly held by the scholar-painters when he
remarked in an anthology of his essays: "Although all people are
the same with respect to painting skills they are different from
each other as long as their ideas are concerned. The art of
scholars is aimed at delineating their mind by allegorical
means, while the art of commoners is, in the main, simply
concerned with portraying what comes into their vision.
Therefore, those whose art depicts the objects that come
before their minds are subservient artisans who sell their skills
for bread. The artists who paint by allegorical means are, so to

speak, seekers of the exquisite principle of the noble and elegant mind...."

As Kang explaind in his essay on painting, scholar painting transcends the visionary sense and ignores shape. It is aimed only at symbolizing the world of ideas by means of employing a brush and Indian ink. Figures depicted on the canvas, which are reflected on our sense of vision, complete their mission only if they suggest the painter's world of ideas or his state of mind. Therefore, in scholar painting, the painter should not necessarily be restricted by the object or he need not make an effort to paint the object as accurately as possible.

This tendency was given birth by spiritualism which constitutes the essence of not only scholar painting but also all the formative arts of the Orient. Chang Yen-yüan, discussing the utility of painting, said: "Painting is conducive to enlightenment, promotes ethics, is mystic and multivarious, and recondite and subtle. Its contribution to the mind can be compared to the Six Books."

To expand on his explanation, scholar painting, especially its ideological aspect, must be understood as something akin to religious faith or morality. If a painting fails to represent the painter's inner self or the root of his profound thought, it can hardly be considered a painting.

In scholar painting bamboo symbolizes the noble mind and tastes of the gentleman who is devoted to fidelity and knows no withering throughout the four seasons. "The chrysanthemum in biting frost, the plum-blossoms in the snow, and the orchid fragrance in a deep ravine" are themes of scholar painting which also symbolize a gentleman's constant fidelity.

The spiritualism manifested in scholar painting goes to extremes as a means of confessing what is in the mind of a painter, as in the case of "The Exposed Orchid Root" executed by Cheng So-nan, one of the surviving retainers of the

Southern Sung court. Painting the orchid together with its root, after his country was overrun by the invading Mongolians, he explained his work: "Now my fatherland has already been defiled by the northern barbarians. How can I dishonor the fragrant root of the orchid with dirty soil?" He painted the root in scarlet, the color to symbolize his ardent patriotism.

The neglect of skills in scholar painting (which goes to such extremes as to claim that the object to be copied on the canvas can and should be ignored) had a decisive influence on the destiny of the dynasty painting as a whole. No matter how the appearance of an object is ignored and what effort is made to describe only the dignity which emanates from the personality of the painter, painting still remains in its domain and should observe the rules required of it whether painters draw a picture without an object or merely copy an object. Breaching a fundamental rule of painting so that they could describe their thoughts in an allegorical way, the Yi dynasty literati comforted themselves by believing that they understood *Mun'gi* (elegance deriving from the possession of an advanced culture). They despised as *Yusu* (literally, "stink of rotten Confucianism") those professional painters who were ill disposed toward scholars and their painting.

Mun'gi is the unique fragrance emitted only by gentlemen who are highly cultivated in Confucianism and whose personalities are lofty and refined. It can also be expected from scholars who are proficient in not only letters but also calligraphy and painting and who possess a thorough Confucian view of life. To emit *Mun'gi* was the ideal of all the gentlemen of the times. The best scholar painting, needless to explain, should be one that embodies the ideal image of a gentleman — a tasteful work by a scholar who has lived up to that ideal.

Explaining *Mun'gi*, Kim Chŏng-hŭi remarked: "It should infallibly consist of fragrance of letters and elegance of books. If one undoubtedly possesses the two, one can spontaneously

learn painting even without first practising with the brush."
Although the Yi dynasty scholar painting was born of a high
standard of culture acquired by scholars, it was later
evaluated only according to how well it described the
personality or ethical view of a painter and confusion crept
into evaluation. Because of the attitude refusing to regard
scholar painting as painting, it was faced with an obstacle
hindering its further development. In the meantime, in the
circle of professional painters the inheritance of skills was
respected above all else. The evolution of a free spirit, which
was the original motive of scholar painting, was later confined
in the biased world of *Mun'gi*.

As *Mun'gi*, like their social privileges, was monopolized by
scholars, it served as a weapon of their tyranny against
professional painters. By placing overconfidence in *Mun'gi*
and abusing it excessively, however, scholars unintentionally
courted their own degeneration. Their self-righteousness as
manifest in their painting functioned also in the field of
philosophy leading them to denounce as heretical all doctrines
other than Chu Hsi's Neo-Confucianism.

Mun'gi is, so to speak, a kind of fragrance and to impart it to
others it must be given a shape. To give it a shape, ability of
expression or painting skills are needed in scholar painting.
Skill in painting is not something, contrary to what Kim
Chŏng-hŭi believed, acquired at birth. When Hŏ Yu
demonstrated his special ability of drawing with his fingertips,
Kim Chŏng-hŭi was unreserved in his fingertips, Kim Chŏng-
hŭi was unreserved in his praise: "... He truly did fine. He
destroyed the hackneyed style which has persisted in our land.
Before him nobody east of the Yalu River produced a work
comparable to his." However, this writer is of the opinion that
his style was indicative of the fact that scholar painting had
already fallen victim to the deformity and degeneration
characteristic of the latter years of the Yi dynasty.

The professional painters whom scholars despised so deeply
were cruelly oppressed under the strict caste system and

confined to the already fixed framework of their hereditary profession. They merely copied the objects they were asked to paint without any research into the art of painting or meditation on the subject. Those who belonged to the more accomplished group were allowed to paint the portraits of kings and ranking government officials. Some of them, succumbing to the vogue of their times, imitated scholar painting.

If the academism of the government office of painting had been given a position equivalent to that enjoyed by scholar painting, the overall character of the dynasty painting would have been considerably different. As the latter was, in fact, strictly distinguished from the former just as the social classes of professional painters and scholars differed, academism became subordinate to scholar painting. In this situation academism had to flatter scholar painting by imitating the latter's style with servitude. Would-be scholar painters appeared in succession sending out worthless products. It should not be overlooked that the dynasty scholar painting made the serious mistake of crushing any attempt to adopt China's academism and further develop it.

Professional painters, with few exceptions, were not allowed to enjoy mental leisure for the appreciation of others' works or for meditation. They were also devoid of any ism or assertion. They lacked personality. It may be that because they had no ism, assertion or subjective view their paintings contain no trace of affectation or virulence which often spring from an inclination toward taste. Their paintings reflect a simple, naive and utilitarian common mind admitting no artificialization. This is especially true with what now remain among the dynasty portraits.

Their paintings reflect their diligence as professional painters who did their best to learn the traditional skills without making any effort to boast their special ability if there was any or showing any trace of their being overwhelmed by a certain style. The portraits they painted also show no effort to paint the most perfect portrait. Most of their products are just

devoid of unreasonableness. In this respect they are in sharp contrast to scholar paintings which can both reach the highly spiritual level and at the same time fall into indescribable depth of degeneration.

Lastly we shall review the influence the Yi dynasty scholar painting had on the Japanese fine arts. All admit that the Japanese painting is rich in and sensitive to colors. The Japanese imported a great number of Indian-ink pictures from Korea in the early part of the Yi period.

Indian-ink works executed by Japanese artists, indicative of their national character, are colorful and distinctive in shade. This is because Indian ink performs the role of five colors. As Wang Wei said that of inks for painting Indian ink is best, the Orientals find five colors in Indian ink according to the degree of its shading. In using Indian ink, a painter should be able to distinguish five colors. Black and white stand at the extreme opposites. It is quite astonishing that ancient painters sensed many different colors, often more than three between those two extremes.

Scholar painters of the Yi dynasty, however, despised such a color sense. As Indian-ink painting departed from all colors except white and black, the Yi scholar painting ceased to utilize the five colors of Indian ink in order to reproduce the spiritual depth or height in a simple and mystic manner. The Japanese, on the contrary, developed their fine arts to a remarkable degree by importing the technique of utilizing Indian ink which the Yi dynasty scholars ignored.

As Yukio Yashiro mentioned in his "The Characteristics of Japanese Fine Arts," it was after 1338, when the Muromachi Shogunate took power, that painting became an object of taste in the true sense. The originator of Japanese Indian-ink pictures was Nyosetsu (a Chinese priest who became a naturalized Japanese and resided at Shokokuji Temple in

Kyoto in the 1400s). He had a disciple, priest Shubun, and under him there was the famous artist-priest, Sesshu (1417-1503).

What promoted the introduction of Indian-ink art to Zen circles in Kyoto where it was received as a new and unfamiliar style of painting? In 1423, the fifth year of the reign of King Sejong, Shubun visited Korea, according to the Chronicle of the Yi dynasty. Shubun, to further explain his career, was a painter-priest resident in Shokokuji Temple in charge of supervising its administration who received a special favor from Shogun Yoshinori Ashikaga. He came to Korea as a member of a 135-man Japanese mission which visited this country for the purpose of obtaining the Tripitaka plates. He stayed in Korea for about four months and when the mission left for home he presumably took Korean Indian-ink pieces back with him.

Shogun Yoshimitsu Ashikaga was an avid collector of paintings executed by Sung and Yüan masters from Korea as well as from China. In 1410, the 10th year of King T'aejong's reign, Yang Yu, the magistrate of Haeju, was sent to Japan as a Korean envoy, and a Korean painter proficient in landscape painting who accompanied the envoy executed "A Plantain in Night Rain" for the Japanese and 16 Zen priests in Kyoto added their poems to the picture. This is indicative of the fact that Indian-ink art was already in vogue in Japan by that time.

If Shubun, who taught Sesshu, was responsible for the rise of Japanese Indian-ink pictures, it is vitally necessary to make a detailed research into the influence the Yi dynasty scholar painting exerted on the Japanese art. This writer was told that research along this line is under way in Japan. Perhaps Korean Indian-ink pictures executed in the early part of the Yi dynasty which are almost extinct in Korea now, may be found in Japan if such research proves fruitful.

Korean Painting of
the Late Chosŏn Period in
Relation to Japanese Literati Painting

HONG SŎN-P'YO

Korean-Japanese diplomatic relations, which had been disrupted during Hideyoshi's invasion (1592-1598) of Korea, were normalized with the inception of the Tokugawa shogunate. After normalization Korea began to dispatch large missions to Japan. The missions numbered as many as 500 members. They included a few professional painters and a considerable number of scholars who excelled in poetry, calligraphy and scholar painting, and artistic contacts of this period between the two countries seem to have been much more active than is generally thought. Through these contacts, Korean painting of the late Chosŏn period is believed to have had a considerable influence on the development of Japanese art practised in the tradition of scholar painting and this possibility provides us with a new subject in the study of artistic relations between Korea and Japan.

However, no serious study has yet been attempted on this subject. This article is primarily an attempt to arouse interest in this new subject, a basic study directed toward the promotion of more systematic research to be undertaken by interested art historians. Let me begin by studying the close relations between the Korean kingdom and the Tokugawa shogunate and styles of paintings actually rendered by members of the Korean mission to Japan.

54

Painterly Relations

Contacts of painting of the two countries were chiefly made through members of the Korean diplomatic mission to the Tokugawa shogunate as part of an active cultural exchange. As a matter of fact, the Korean royal government and the shogunate of Japan maintained very friendly relations. While the Korean kingdom, weary of frequent foreign invasions, was in pursuit of peace and security, the shogunate of Japan sought to develop Confucian culture in preference to the overriding Buddhism as a means to discover a fresh national outlet. Since these national policies of the two countries were in parallel with each other and were politically coincidental, the relations between the two governments were more peaceful and active than any other period.

An extant evidence of close relations can be seen in "*Tsuko Ichiran*," a complete record of Japanese foreign relations compiled in the Edo period (1615-1816). The chapters devoted to the Japanese relations with China amount to only one ninth of the volume, whereas the chapters devoted to Japanese relations with Korea amount to one third of the whole book. This fact alone suffices to explain the Japanese situation of the period.

In Japan, Zen priests formed the intellectual class. They were consulted on national affairs and were even commissioned to write or read diplomatic documents. But a notable fact is that they were replaced by Confucian scholars. Zen priests participated in entertaining members of a mission from Korea, but the chief hosts were always Confucian scholars, and among the Japanese literati painters of Confucian background were Gion Nankai (1676-1751), Nakayama Koyo, Ikeno Taiga (1723-1776), and Uragami Gyokudo (1745-1820). Gion Nankai, who entertained Korean scholar-artists, was a pioneer of the Southern School and a disciple of Kinoshita Junan (?-1698) who was trained by Fujiwara Seika (1561-1619).

During their five to eight months of stay in Japan, members of the Korean mission kept themselves extremely busy complying with innumerable requests of Japanese intellectuals to render paintings and calligraphic works or to write poems for them.

In his diary (東槎日錄), Kim Chi-nam stated that Japanese government leaders, scholars and even servants kept coming to him to make such requests which he could not refuse. In his *Haeyu-rok* (海游錄 Account of Overseas Experiences), Sin Yu-han said:

"Japanese literati travelled from afar to visit us and request our poems, paintings and calligraphies. They admired Choson culture so much that aristocrats and ranking officials were proud of having obtained our paintings and writings. Having had something from us, students found it a great honor, and people of a lower class watched us with curiosity." These records reveal enthusiasm for advanced learning achieved by Koreans, enthusiasm of people from all walks of life in Japan.

Some Korean painters and calligraphers had complained that they were not getting enough sleep to comply with Japanese requests. Thereafter the Japanese shogunate came to restrict such request. But art works rendered by Koreans were so much prized by the Japanese that even a bribe was offered on occasion.

Whenever a Korean mission arrived in Japan, the shogunate received the Koreans with utmost hospitality, spending some one million *ryo* of money and employing more than 1,000 laborers at the quay. And for the Koreans' travel from Kyoto to Edo, some 230,000 people and 40,000 horses were mobilized.

In response to the Japanese hospitality, the Korean royal government dispatched the mission to Japan with care. The mission to Japan comprised some 500 persons, whereas the mission to China was made up of only 200 to 300 people. Members of the mission were selected more carefully than ever. The mission was to include one professional painter and

two stenographer-recorders, according to such historical records as *T'ongmunkwan-ji* and *Taejŏnhoe-t'ong*. In effect, however, each mission included two painters and three or four recorders. When Yi I-jang led a mission to China in 1751, during the 27th year of the reign of King Yŏngjo, the roles of these specific members had been neglected.

Members of the Korean mission are believed to have left a large number of their paintings in Japan at the request of the Japanese. Only a portion of them are mentioned in Japanese records, such as *Chosen Shogaden* (Korean Calligraphy and Painting) in *Koga Piko*. Here let me take note of those related to the development of the Japanese Southern School, *Nanga* or scholar painting which depended upon inspiration rather than a studied technique.

As Dr. Ahn Hwi-joon (An Hwi-jun) has noted, the Southern School of China was introduced in Korea in the early 17th century and was followed by a few Korean artists of progressive vein. Among the Korean painters related to the Southern School were Yu Sŏng-ŏp, Yi Hong-kyu (1568-?) and Yi Ki-ryong (1600-?) who had been dispatched to Japan. They were relatives of Yi Chŏng-kŭn (1533-?) whose painting titled *"Landscape of Mi Fu style"* is in the collection of the National Central Museum of Korea. Yi Chŏng-kŭn was a painter who experimented in the Korean Southern School. If the three painters of the Korean mission to Japan had inherited Yi Chŏng-kŭn's landscape style, it is possible that the Southern School was introduced in Japan already in the first half of the 17th century. But their paintings are not extant and we cannot be positive about this.

The Southern School of painting was favored in Korea in the 18th century, and we can assume that this style was followed by the Korean painters who were sent to Japan from the 18th century onward.

The head of the Korean mission sent to Japan in 1711-1712 was Cho T'ae-ŏk (1675-1728), a noted scholar painter in the tradition of the Southern School. He had been accompanied

by painter Pak Tong-bo. He was received in Japan by Gion Nankai of Confucian background. He excelled in poetry, calligraphy and painting and met with Japanese Confucian scholars, writing poems and painting landscapes. Unfortunately, none of his paintings have survived. There is, however, an indication that Cho T'ae-ŏk had been familiar with the Southern School style of Wen Cheng-ming, a principal figure of the Wu school of the Ming period. In his *Sokai Iju,* Gion Nankai stated that while in Edo in 1711 he became familiar with Southern School painting and copied works of Southern School painting. This is related to the fact that Cho T'ae-ŏk was in Edo in the same year and met him there.

Pak Tong-bo is also believed to have been an important figure, though his paintings of the Southern School no longer exist. Upon returning from Japan in 1713, he met Kim Chin-kyu, also a scholar painter who commented that there is "a willful inspiration in Pak Tong-bo's painting." From this we can assume that Pak followed the Southern School that emphasized the importance of inspiration. In fact, his *Plum* is akin to *Plum in Ink* by Gion Nankai in style and approach. There is a strong possibility that his activities in Japan had much to do with the development of the Japanese Southern School. Ham Se-hŭi was a member of the Academy of Painting dispatched to Japan in 1718. He was a painter of a landscape titled *Landscape of Puyong-bong Peak,* according to *Chosen Shogaden* (Korean Calligraphy and Painting), but none of his paintings are in existence.

When Ch'oe Puk and Yi Song-nin (1718-1777) visited Japan in 1747-1748, they seemed to have contacts with Japanese painter Nakayama Koyo. Ch'oe Puk was a member of the Academy of Painting who followed the landscape style of Chŏng Sŏn. Kim Yu-sŏng (1725-?) and Pyŏn Pak went to Japan in 1763-1764. Kim Yu-sŏng's painting, a screen titled *Painting of Landscape with Birds and Flowers,* is still preserved in the Seiken-jin Temple in Japan. His *Painting of the Diamond Mountains* rendered on the screen is closely related to the style

of Uragami Gyokudo, a Japanese painter of the Southern School. As Cho Ŏm stated in *Haesa-Ilgi*, Kim produced the landscape at the request of the abbot of the temple.

Pyŏn Pak was a painter from Pusan who also followed the style of Chŏng Sŏn. Chŏng Sŏn (1676-1759) based his landscapes upon actual Korean scenes and Korean subjects, recommending painting from nature with emphasis on a direct and close study of it and therefore marking a departure from the scholar's painting done in the privacy of his studio. For this reason his landscapes done in Japan were interpreted as "new Korean landscape paintings" in *Chosen Shogaden* (Korean Calligraphy and Painting). It is provable that his landscapes were interpreted as such in Japan.

In addition to these paintings extant in Japan, a considerable number of other paintings of characteristically Korean style are to be found in Japan. Some of the Korean paintings could have been brought to Japan by members of a Korean mission, and others could have been brought to Japan by members of a Japanese mission in Tongnae. These unknown paintings are also believed to have played a role in the development of the Japanese Southern School.

Latter Choson Painting and Japanese Southern School

Thus Korean paintings played a considerable role in the development of the Japanese Southern School. Chinese paintings could have also made a contribution in Japan. However, the development of the Japanese Southern School was largely due to active cultural exchange between the two countries after Hideyoshi's invasion of Korea.

The origin of the Southern School, also called literary or scholar painting, may date back to the T'ang dynasty of China. But it largely developed during the Yüan dynasty (14th century). It was introduced in Korea in the 17th century, at latest, and was transmitted to Japan a century later. This style

of painting was practised by limited circles of literati who were not professional painters but amateurs in the best sense of the word. Their paintings were not sold. They were rather given to friends or relatives, because these painters did not rely on painting for a living. This is one factor for the belated advent of the school in Korea and Japan.

In Japan, the growth of the Southern School was made possible by dint of a new social trend in which learning was held in high esteem. Also stimulating the Japanese interest in the Southern School were the visit to Nagasaki of Chinese Zen priests, the visit to Japan of 伊海, a Ch'ing merchant and a painter of the same school, the arrival of collections of reproduced Chinese paintings, such as Hasshu gahō and Chjeh-tzu-yüan Hua-chuan, as well as the introduction in Japan of books on Korean paintings.

Chozo Yamauchi has asserted that some of the Chinese paintings known in Japan had been paintings by Koreans bearing signatures and seals of Chinese painters. It was quite possible in the period between the late 17th century and early 18th century when the Japanese imported Chinese culture through Korean ports, namely Tongnae near Pusan.

The book of Chinese painting titled Chieh-tzu-yüan Hua-chuan stimulated Japanese artists in the development of the Southern School. The introduction in Japan of this book was also associated with Korean artists. According to Kaijakugawa written in 1829, Gion Nankai acquired the Chinese book for the first time in Japan in 1712. It was in the same year that Gion Nankai met members of the Korean mission.

On the other hand, we can also trace the Japanese interest in Korean paintings in chapters devoted to Korean calligraphers and paintings in Koga Biko by Tani Buncho. The account on Korean artists contained reproductions of Korean paintings and calligraphies found in Japan early in the 19th century. Discerning Korean painting from Chinese, Tani spoke of Korean paintings as containing "Korean flavor."

From what we have so far observed we can at least recognize

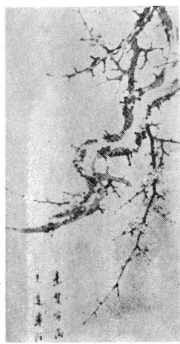

Plate 1 *Black Plum* by Gion Nankai

the active role played by Korean painting in the growth of the Japanese Southern School. Now let me take a glance at the Japanese Southern School in connection with Korean paintings introduced in Japan.

As we have already noted, Gion Nankai met with Korean artists who were in Japan on a diplomatic mission in 1711-1712. We must note that his *Autumn Landscape* done in 1707 is void of any flavor of the Southern School. From this fact we can deduce that he had not achieved a "southern style" before he had contacts with members of the Korean mission to Japan. Among his works associated with Korean painters of the late *Chosŏn* period are a pair of ink paintings, *Black Plum* (Plate 1) Yamauchi pointed out that there is a stylistic affinity between Gion's ink paintings and a pair of *Plum* by Pak Tongbo (Plate 2) who was a member of the mission in 1711-1712.

The paintings of plum are akin to each other in composition and the shape of the plum tree. The gnarled plum branches in Gion's ink painting are even similar in taste to "An Old Camellia" by Chŏng Sŏn. Gion's painting of plum tree in ink is characterized by its flat tree trunk, its pointed branches and delicate blossoms, and these elements are indeed idiosyncratic to Korean ink painting of plum trees.

We can trace the basically same stylistic development in his later ink painting of plum in the collection of Kanasuke Wanaka of Wakayama. This painting shows more complex branches and more fragile-looking blossoms. But it is still akin to Korean style in his treatment of the tree trunk and blossoms and in his brush strokes.

His *Landscape* in the National Museum in Tokyo is especially noteworthy. The landscape is made up of three

Plate 2 *Plum* by Pak Tong-bo

sections, the foreground, middle part and background. It is somewhat Korean in style in the method of rendering dots that form the mass of a mountain. Chŏng Sŏn's style can be detected in the paintings of Nakayama Koyo, a painter of the early period of the Southern School in Japan. From childhood he was trained in Confucian classics. He was in Kyoto in 1748. It was in this year that Ch'oe Puk and Yi Song-nin who followed Chŏng Sŏn's style came to Kyoto while visiting Japan as members of a Korean mission to Japan. Having been a Confucian scholar, Nakayama showed an interest in the visit to Japan of the Korean mission. In his book on painting, *Gadan Keijo*, he described the Japanese enthusiasm for Korean poetry and painting and artistic exchange between the two countries over a long span of time. The book said in part:

"Painting is popular in Korea, and the painters who are in Japan as members of a mission to Japan are outstanding artists. They have studied such Chinese masters as *Tung Yüan*, *Ni Tsan*, and *Shên Chou*, but they show their own styles."

These facts attest to Nakayama's knowledge of and interest in the late Chosŏn painting. In this connection, Motoaki Kono stated that he probably studied the method of Korean painting. His two late works, *Sight of Kisagata Cove* and *Landscape with Lake and Mountain*, provide us with some

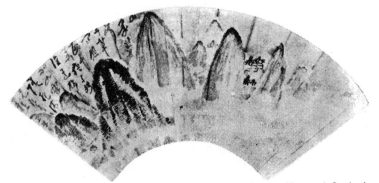

Plate 3 *Overlapping and Towering Clouded Mountains* by Uragami Gyokudo (1745-1820)

clues to this tendency. In the former, he seems to have a Korean flavor in the rendering of pine trees in the foreground and of a round knoll with dots in varying ink tones. A similar touch is also employed in a bare mountain in the background in the latter.

Korean influence is felt in the paintings of Ikeno-no Taiga (1723-1776). In praise of the calligraphy by Yi Su-jang, a member of a Korean mission, he wrote a colophon on one of his works. The knolls and trees in his landscape are rendered with semicircles in light ink tones and dots in darker ink. This technique resembles that of Chŏng Sŏn as illustrated by trees in the middle ground in *Changan Yŏnwu-do* (The Raining Landscape of Changan). And in his landscapes based on actual sketches, such as *The Volcanic Mt. Fuji*, Ike-no-Taiga creates a composition which is surrounded by mountain peaks as seen from above. This type of composition is closely related to that employed in the topographical landscapes of the Chosŏn period.

A stronger Korean influence is felt in the paintings of Uragami Gyokudo (1745-1820), one of the four *Nanga* masters of his time whose mountain landscapes are often inspired in their grand conception of nature. At the age of 10, he entered the Shogunate school and studied Confucian classics. He became a *samurai* (warrior) under a feudal lord but retired in

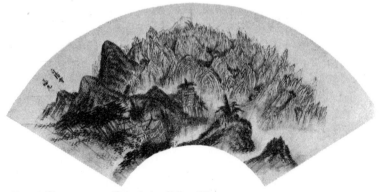

Plate 4 *Chongyang-sa Temple* by Chŏng Sŏn

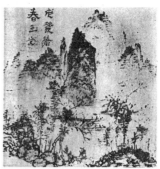

Plate 5 *Landscape of Diamond Mountains* by Kim Yu-sŏng

Plate 6 *Aged Trees in Spring Quietness* by Uragami Gyokudo

his middle age and concentrated on painting. He had studied painting without a teacher. But he visited Edo many times to study painting together with Tani Buncho who compiled *Chosen Shogaden*. Chŏng Sŏn's method of landscape painting is reflected in his landscapes in strong brush strokes.

In his *Overlapping and Towering Clouded Mountains* (plate 3), mountains are formed with dots at left and at right are crags, and this painting is similar in composition to *Chŏngyang-sa Temple* (plate 4) depicting a real landscape of the Diamond Mountains. Both paintings feature misty mountains at the right space. The method of using Mi to depict a mound in Uragami's landscape is especially akin to the method of depicting a mountain in the late Chosŏn painting. The round crags are depicted with a bold touch, and this, together with a bold line in deep ink tones, seems to have been based on the method of brush strokes employed by Chŏng Sŏn. The semi-conic rocky mountains in this painting also resemble those in *Landscape of the Diamond Mountains* (plate 5) rendered by Kim Yu-sŏng in Japan in 1764.

Uragami's *Aged Trees in Spring Quietness* (plate 6) is also Korean in character. The foreground features a bridge in between two sections of hilly scenes, and in the background are mountain ranges with pointed peaks. The prototype of such landscapes may be seen in *P'yohun-sa Temple* (plate 7) by

Ch'oe Puk who was in Japan in 1747-1748. In his later work titled *Meandering Pass in Hilly Land*, mountains are rendered in arch shapes with horizontal touches like the mountains found in Chŏng Sŏn's *Manp'okdong* in the collection of Kansong Art Museum. A Korean influence can be also traced in his sketchy pines and bold strokes of the brush.

I have briefly examined the influence of late Chosŏn painting on the Japanese *Nanga* (Southern School). But my observation remains too sketchy and does not reveal the deeper relations between Korean and Japanese paintings. This article is merely an attempt at stimulating more comprehensive research into the subject among interested students of art. I hope that this field will be studied systematically and comprehensively in the future.

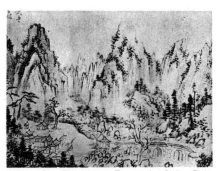

Plate 7 *The P'yohun-sa Temple* by Ch'oe Puk

Korean Genre Paintings in the Netherlands and around the World

BOUDEWIJN C.A. WALRAVEN

Which Korean painter was best known in the West around 1900? Strangely, there will be very few people nowadays who are familiar with his name, although his work, which consists of depictions of scenes from daily life in Korea, still has considerable documentary value and a charm which cannot be denied, even if it does not belong to high art. It is the purpose of this article to introduce this man and his work, beginning with a brief description of Korean genre paintings in Dutch museums.

Pictures of daily life in Korea before the end of the Yi dynasty are comparatively rare. There were only a few illustrated books, and such as there were—works describing paragons of Confucian virtues, Buddhist scriptures, a handbook on martial arts and other books of a technical nature—do not contribute to our knowledge of the daily aspects of traditional Korea. Before the 18th century when such important genre painters as Kim Hong-do and Sin Yun-bok emerged, most painters followed Chinese models and did not draw scenes from life. Even in the 18th century the total number of genre paintings was not very large, while the 19th century again shows a decline, both in quality and in quantity. What is rare gains in value, and for this reason every painting or sketch providing information about life in the past deserves attention. No doubt, a search for such material will reveal

much that has long been hidden; even a small and far-away country like the Netherlands has something to offer in this respect.

As said above, Korean genre painting came into its own in the 18th century. Nevertheless, the Dutch museum of Maritime History in Amsterdam possesses a Korean painting of a much earlier date, which may be regarded as a genre painting. It is called *The First Making of Ships and Chariots* (始作舟車). This oblong painting, mounted as a vertical scroll and measuring 210 × 56 cm, is drawn mainly in black ink, with touches of red and green. In the middle one sees a group of seven people in Chinese dress such as was worn during the Ming dynasty (1368-1644). They are surveying the activities of workmen who are building two boats and a number of chariots. The figures in the center presumably are the legendary Yellow Emperor of China, who is credited with the invention of both ships and the wheel, and his attendants. Their formal dress and immobile attitudes contrast sharply with the lively workmen, who, armed with hammers, saws, planes and chisels, display great activity and remind one of the plebeian workmen in some of Kim Hong-do's pictures. A theme from traditional history was seemingly used as a pretext to depict scenes from daily life.

In Western art similar phenomena are found during the early Renaissance. The trend was from religious painting towards secular painting, but the change was not abrupt. One finds intermediate stages, like a painting which has as its theme Maria with the infant Jesus, but which to the uninitiated observer appears as any mother with her baby. The title of one such picture (by the Dutch painter Gerard David, C., 1460-1523) illustrates the fusion of religious art with secular genre painting; it is called "Madonna with Porridge Spoon."

The First Making of Ships and Chariots bears the seal of a 16th century scholar, famous for his calligraphy, Sŏng Su-ch'im 成守琛 (1493-1564), who used the pseudonym

Ch'ŏngsong 聽松.[1] If he had not painted this work himself, he may have used his seal to indicate his ownership. Unfortunately, so far it has not been possible to trace the origins of this work beyond 1959, the year in which the museum acquired it.[2]

The remainder of the Korean genre paintings in the Netherlands date from the 1880's. At that time — about a century after Kim Hong-do (1745-?) — a small number of Westerners visited Korea, which had been opened to the world in 1876, but still was hardly influenced by outside forces. The genre paintings under discussion are closely linked to the appearance of these Westerners, as we shall see, but they are also connected to the work of Kim Hong-do. A description of the sketches kept by the Dutch National Museum of Ethnology at Leiden will serve as the basis for a survey of the genre to which they belong. There are thirty-six sketches in small *quarto*, of which thirty-two are done in black ink and four in color. Twenty-three are by an artist who used a seal with the pseudonym "Kisan" 箕山, and thirteen are by an artist with the pseudonym "Sŏkch'ŏn" 石泉. The pictures were presented to the Dutch government by J. Rhein, secretary and interpreter at the Dutch legation in Peking, in 1889. Rhein also sent eleven much larger paintings (in *folio*), all in color and unsigned, although they bear an explanation in Chinese characters. These explanations were obviously written by a Chinese unfamiliar with the Land of the Morning Calm. For Korea the term Chosŏn (Chinese: Chao-hsien) 朝鮮, is usual, but Koryŏ 高麗 (Chinese: Kao-li) was used, by which the Chinese referred to Korea even after the fall of the dynasty of that name. These explanations also contain some amusing mistakes: a picture that without any doubt represents a shaman, a *mudang*, a figure belonging to the lowest class in traditional Korean society, is described as "a young Korean lady." A picture of an unmarried boy with the customary long pigtail is said to represent a "Korean girl." His facial features are rather feminine indeed, but his dress is that of a Korean

man. These mistakes testify how different the culture of Korea was from that of China, its closest neighbor and cultural model for centuries.

While the larger paintings just show single figure from all walks of life — military officials, government messengers, an actor, a *mudang*, a blind fortune-teller and such — the sketches by Kisan and Sŏkch'ŏn show all kinds of activities: merchants, children at play, artisans at work, a doctor treating a female patient with acupuncture and monks making music, to mention only a few of the subjects.

When I saw these pictures for the first time, some of them looked familiar. Soon it became clear that many similar sketches were used to illustrate books about Korea published in the West at the close of the 19th century. Most of these were by Kisan. Twenty paintings bearing Kisan's seal are reproduced in *Korea and the Sacred White Mountain* by A.E.J. Cavendish and Henry Goold-Adams, two British army captains who

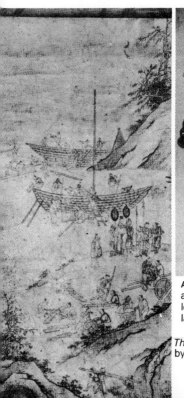

A *mudang*. Large colored picture by an anonymous artist, with the misleading caption: "Young Korean lady"

The First Making of Ships and Chariots by Ch'ŏngsong.

An actor. Large colored p by an anonymous artist.

traveled in Korea in 1891.[3] Six of these are reproduced in color, although originally all of them seem to have been colored. These pictures are, on the whole, more elaborate than the sketches in Leiden. Themes of several separate sketches in the Netherlands here often are combined in one picture. In 1888 or 1889 the French ethnographer Charles Varat obtained thirty-six Kisan sketches which he used to illustrate his articles for a French magazine called *Tour du Monde*, a kind of 19th century *National Geographic Magazine*.[4] In 1895 *Korean Games*, by an American anthropologist Stewart Culin, appeared, illustrated with twenty-two excellently reproduced sketches by Kisan, all in color.[5] Thirty illustrations in *Life in Corea* by William R. Carles, British vice-consul in Korea in the early 1880, are stylistically so close to Kisan's work that it is hard to imagine that they would be the products of another artist.[6] The pictures in Charles Chaillé Long's *La Corée ou Tchösen*, published in 1894, seem to be rather clumsy redrawings of sketches by Kisan or a kindred artist.[7] Original paintings by Kisan were exhibited in 1895 in the Museum for Arts and Crafts (Museum für Kunst und Gewerbe) in Hamburg, Germany. These paintings were part of the Korean art collection of H.C. Eduard Meyer, head of the firm of H.C. Eduard Meyer & Co. (In Korean Sech'ang yanghaeng 世昌洋行), which had been active in Korea since 1884, supplying the Korean government, *inter alia*, with modern minting machinery and offering a substantial loan.[8]

Before 1900 already more than a hundred of Kisan's paintings had been made public in the West, enough to justify the claim that at that time no Korean artist was better known among Americans and Europeans. Of course, this means little, given the almost complete ignorance about Korean art which then prevailed in the Occident, but still the role of Kisan in the propagation of knowledge about Korea should be highly valued. Without his illustrations the readers of the books mentioned above would certainly have visualized Korea as a kind of China or Japan, countries relatively well-known

A *mudang* divining the future for two female customers by Kisan.

An artisan making brass-ware by Kisan.

through representations in various forms.

Kisan's work also appeared in Western publications after the turn of the century. Two sketches by him are found in the *History of Korean Art* by the German pioneer of Korean Studies, Andreas Eckardt, published in 1929,[9] and in 1958 a monograph devoted to Kisan appeared in Leipzig, East Germany, written by Heinrich Junker, a scholar mainly concerned with Korean linguistics.[10] This book contains forty-five paintings by Kisan, of which some are rather unusual, as they depict landscapes. The difference between these landscape paintings and Kisan's genre painting, however, is not as big as might be expected; human activity is always an important part of the landscapes.

A review of the works of Kisan mentioned above shows an amazingly wide range of subjects. He depicted all kinds of children's games: blindman's buff, flying kites, seesawing, swinging, playing at dibs and spinning tops. There are also the more serious or even gruesome aspects of life; for example, three men wrenching sticks between the bound legs of a

criminal (?), while a clerk keeps his brush poised above the paper to record the confession extracted in this way. To return to more pleasant subjects, Kisan painted people making music or enjoying a drink in the company of pretty ladies, tightrope walkers, frail dancing girls riding on the backs of their male companions with a long pipe between their crimson lips, actors performing a mask play, a singer of *p'ansori* and men passing time with games such as Korean chess, backgammon or *yut*.

Of special interest are the pictures he made of artisans of every description. Kisan, for instance, sketched all the stages of the production of cotton, from the growing of the plants to the weaving of the cloth. Even a picture of a cotton merchant can be found. One picture may explain more than many words. Mere verbal explanation will hardly suffice to make clear the curious way in which some kinds of noodles were made by a man hanging from a rope, his feet resting on the rungs of a ladder, his body almost completely horizontal, while with his buttocks he pressed a wooden lever. Kisan also provides information about hat making, pottery, metal working, tile making, bow making, lathe working, ore smelting, hemp making, furriery, grain milling, oil pressing, sieve making, weaving, silk production, cobblery and basket weaving. He painted the tasks of the farmer during the four seasons, fortune-tellers, beggars, successful candidates in the government examinations, hunters, highwaymen, blacksmiths, a master of geomancy looking for a favorable site for a grave in the company of a man dressed in mourning, a brawl in the streets, an itinerant porcelain mender, the cremation of a Buddhist monk, weddings, birthday parties and funerals.

Who was Kisan? Hints are given by some of the books mentioned above. Cavendish in the introduction of his book tells us that "The native sketches were executed for me by a Korean gentleman...." Culin says that the Korean illustrations in his book "...are faithful copies of a series of colored pictures made by Kisan, an artist in the little Korean

village of Tchoryang (= Ch'oryang 草梁), back of Fusan (= Pusan 釜山). They represent the people of that locality. They were executed in 1886 upon the order of Miss Shufeldt, daughter of Rear Admiral R.W. Shufeldt, U.S.N., who visited Korea upon the King's repeated invitation just four years after Admiral Shufeldt had negotiated the treaty between Korea and the United States." According to Junker's book, Kisan's pictures were presented by King Kojong to Paul Georg von Möellendorf, the German adviser to the Korean government in the middle of the 1880s. Kisan's real name is not given in these books. The answer to that question is on a long horizontal scroll kept in Sungjŏn University Museum in Seoul, on which more than a hundred separate sketches of Korean life are pasted. One picture on this scroll not only has the familiar seal of Kisan, but also an inscription which reveals the full name of the painter: "Kim Chun-gŭn from the Korean harbor of Wŏnsan" 朝鮮元山港 金俊根. Another picture at the opposite end of the scroll has the inscription: "Drawn by Kisan of Korea" 朝鮮國 箕山寫 and two seals: "Kisan" and "Seal of Kim Chun-gŭn."[11]

The name of Kim Chun-gŭn may be known to those who have studied the history of the Christian missions in Korea. He is the very artist who drew the illustrations for the first Korean translation of a Western literary work, i.e., that of John Bunyan's *Pilgrim's Progress* (in Korean: T'yŏllo Ryŏktyŏng 天路歷程), translated by the Canadian missionary James Scarth Gale, who lived in Wŏnsan from 1892 until 1897. The illustrations to this book, which appeared in 1895, can also be seen in Sungjŏn University Museum, where they are mounted on a horizontal scroll similar to the one with Kisan's genre paintings. The illustrations are almost completely Korean in style, and all the figures wear Korean dress. Only where Korean traditions were lacking, for instance, for the depiction of devils and lions, Western touches are to be discerned.

The full name of Kisan's fellow artist Sŏkch'ŏn probably was Kim Ye-ho 金禮鎬. His pictures bear a seal with rather

ornately carved characters. The second one, being the first character of his given name, is hard to decipher. Nothing more about Sŏkch'ŏn is known to me, but what we know of his full name suffices to conclude that he was not one of the painters using "Sŏkch'ŏn" as a pseudonym whose names appear in handbooks. Both Kisan and Sŏkch'ŏn would probably have been very minor artists if they had been professionals, and they might have been amateurs. One wonders whether Cavendish's remark that he received the sketches from "a Korean *gentleman*" (emphasis added) should not be taken to mean that Kisan was a non-professional artist.

From the above it is obvious that Kisan and similar artists made their sketches to meet the demand from early Western visitors to Korea who were eager to learn as much as possible

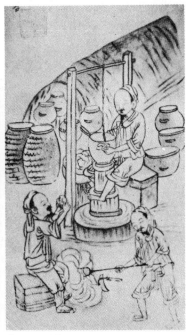

Actors (*kwangdae*) perform a scene from a mask-play.

Potters, with a kiln in the background, built against the slope of a hill by Sŏkch'ŏn.

about this mysterious kingdom. On the other hand, they were firmly within Korean tradition. To begin with, their subject matter in many cases is exactly the same as that of Kim Hong-do and Sin Yun-bok. Farmers at work, *kisaeng* making music, artisans and traveler, are found in the works of the 18th century masters as well as in those of the 19th century artists. The latter have more in common with Kim Hong-do than with Sin Yun-bok — they share a slightly caricatural, humorous touch with the former, while they have none of the romanticism and painting effects of the latter — but nevertheless it is interesting to compare some of Sin Yun-bok's more simple sketches, e.g. of women selling fish or ironing clothes etc., with Kisan's pictures.[12]

The work of Kim Hong-do's son, Kim Yang-gi 金良驥, also shows similarities with those of the last 19th century artists. Kim Yang-gi has left us a painting of men playing cards,[13] which closely resembles a sketch by an anonymous artist who must have been a contemporary of Kisan.[14] It is possible to date this sketch roughly because of a little table seen in another sketch by the same artist. The table is filled with articles of foreign origin: bottles with some foreign liquor, glasses, a corkscrew and a few cans. Therefore, this picture must have been painted after the opening of the ports to foreign trade. That such articles quickly found customers is testified by Cavendish, who in 1891 in Wŏnsan saw for sale: "Manchester shirtings, German needles, Japanese mathes, cheap mirrors, small bottles of dyes, kerosene oil, cigarette papers and occasionally Japanese cigarettes."[15] The presence of Western articles in the sketch incidentally suggests that artists like Kisan were not what one might call "folklore-painters", although Kim Man-hee has reproduced some of Kisan's works in one issue of his *Korean Folklore Pictures*.[16] The folklorist — at least the traditional folklorist — tries to capture the original form free from modern accretions, which he views as distortions. A folklore painter deliberately would have left out newly imported goods, instead of displaying them

prominently in the foreground. To show everything — old and new — together as it coexists in real life, is the way of an anthropologist rather than that of a folklorist.

To return to the historical links of Kisan and his colleagues, not only did they follow in the footsteps of Kim Hong-do, but Kim Hong-do himself, although long after his death, fulfilled the same role as mediator between Korea and the West. A recent article[17] noted that already in 1886 the American magazine *Science* carried redrawings of some of the famous genre paintings by Kim Hong-do.[18] The original pictures were first copied by a Korean of whom only the name in Romanization, Han Jin-o, is known, and for publication in *Science* they were again copied by an American artist. The pictures had been sent from Korea to the National Museum of Ethnography by Ensign John Baptiste Bernadou. Bernadou (Koreanized as Pŏn Odo 蕃於道) was attached to the American legation in Seoul from 1883 until 1885, about the same time when Möellendorf and Carles were in Korea. In the corners of the copies of the paintings of Kim Hong-do, this Han Jin-o sketched objects related to the theme of the painting. The picture of women washing clothes in a mountain stream, for example, also shows some of the objects used to "iron" clothes: wooden mallets and the peculiar iron used to iron collars, called *indu* in Korean. If one now looks at Kisan's sketches, it is not only evident that they fulfilled the same role as the Kim Hong-do paintings sent to the United States, but obvious that Kisan made it standard practice to show in one and the same painting a certain activity as well as the tools needed for its execution and, sometimes, the finished product. His sketch of a brass worker is a good example of this principle.

The article in *Science* states that "Ensign Bernadou has had the good fortune to obtain nearly a hundred-old water color sketches by native artists, portraying industrial life and natural scenery." Not all of these sketches could have been copies of Kim Hong-do, and one wonders if some of Kisan's works were

also included. The article concludes with the following words: "Each of these paintings is as graphic and iñstructive as those [eight pictures] presented. It is very difficult to impress upon the mind of ordinary travellers that it is just the information conveyed in such pictures that anthropologists need." These words may be applied to the works of Kim Hong-do as well as to those of Kisan, Sŏkch'ŏn and their colleagues.[19] At the end of the 19th century this information was mainly of value to foreigners, but now that one century has passed, these sketches deserve to be studied by the compatriots of the artists also. The reissue of an album of Korean genre paintings originally published in 1910 proves indeed that nowadays Koreans show an interest in such matters.[20] More than hundred sketches in this album were drawn by a Japanese, Nakamura Kinjō 中村金城, who visited Korea for the first time in 1904, as an adviser to the Korean government. A comparison of his paintings with those of Kisan, especially those on the scroll in the Sungjŏn University Museum, provides conclusive evidence that Nakamura did not draw from life, but copied the sketches of the Korean artist, filling in the background with houses, trees, landscapes and such. In this way he romanticized the clear descriptiveness of the originals. Although it was his avowed aim to record Korean customs, his renderings of Kisan's work sometimes blur essential details. For example, in Nakamura's picture of a man teaching singing to two girls it seems as if he used only his bare hands to strike the hourglass drum (*changgo*). In Kisan's sketch the stick in the man's right hand is clearly visible. For this reason one cannot but regret that Nakamura's second-hand work has been selected for republication and not that of Kisan.

All over the world there are presumably hundreds of Kisan's works left. As previously mentioned, Sungjŏn University has over a hundred sketches; in Leiden there are more than twenty. In Berlin the originals of the illustrations of Junker's book were exhibited recently.[21] Eckardt mentions that the originals of his Kisan pictures are in the Ethnological Museum in

Munich. Seventy-nine Kisan paintings from the Meyer collection are now in the Hamburg Ethnological Museum (Museum für Völkerkunde). These are particularly valuable, as they were executed with special care. They are all painted on silk (instead of paper as the other sketches known to me) colored and more elaborate than the average Kisan sketch. Only the pictures in the book by Cavendish seem to reach approximately the same standard; the paintings in Hamburg certainly represent Kisan's finest work. In the United States one may hope for the discovery of the originals of the illustrations of *Korean Game* and of the pictures sent by Bernadou. Finally, France may contribute the sketches reproduced by Varat. Properly arranged and accompanied by succinct explanations, these pictures could make an attractive and informative volume on life in 19th century Korea. The appeal of these sketches to a lay public should not be doubted. In the Netherlands, where they have been used to illustrate translations of Korean poetry and traditional stories, the critics unanimously praised the charm of the illustrations.

Fortunately, efforts are already being made to make Kisan's works available to the public. In Hamburg Dr. Gernot Prunner and Dr. Cho Hung-youn are at present working on a publication in which the pictures in Hamburg will be reproduced. Sungjŏn University Museum intends to make the Kisan sketches available in the form of slides. One can only wish that other institutions possessing late nineteenth century genre paintings will follow these examples.

NOTES

1. Kim Yŏng-yun, *Han'guk sŏhwa inmyŏng sasŏ*, Seoul 1959, p. 110.
2. A clue may be found in a small piece of paper, pasted at the back of the painting, with the words: "Ship-building. 16th century Lent by C.H. Sherrill."
3. Alfred Edward John Cavendish and Henry E. Goold-Adams, *Korea*

and the Sacred White Mountain, London 1894.

4. Charles Varat, "Voyage en Corée" in *Le Tour du Monde*, LXIII, 1892 premier semestre, pp. 289–368.

5. Stewart Culin, *Korean Games*, Philadelphia 1895.

6. William R. Carles, *Life in Corea*, London 1888.

7. Charles Chaillé-Long, "La Corée ou Tchösen" in *Annales du Musée Guimet*, Vol. 26, Paris 1894. Challé-Long was in Korea from 1887 until 1889.

8. The Meyer collection is described in: Ernst Zimmermann, *Koreanische Kunst*, Hamburg 1895. See especially pages 9 and 11. A Kisan sketch is reproduced on page 18. For Meyer's enterprises see: Martina Deuchler, *Confucian Gentlemen and Barbarian Envoys*, Seattle London 1977, pp. 190–191.

9. A. Eckardt, *History of Korea Art*, London 1922.

10. Heinrich Junker, *Alte Koreanische Kunst*, Leipzig 1958.

11. The information that Kisan was from Wōnsan is of course in conflict with Culin's statement that he was from Ch'oryang. As there is no reason at all to assume that the Kisan of *Korean Games* and the Kisan of the Sungjōn University Museum are different persons, Kim Chun-gūn must have moved to Ch'oryang temporarily. Apparently he was in Wōnsan in the early 1880s, because Carles tells us that the illustrations were by a "Korean artist from Gensan (= Wōnsan)". As will be shown in the main text, it is most likely that Kisan was back in Wōnsan in the 1890.

12. Yi Tong-ju, *Uri nara-ūi yetkūrim*, Pakyōngsa, Seoul 1974, p. 227 and p. 228.

13. *Ibid.*, p. 236.

14. Several sketches by this artist are reproduced in Yang Chae-yōn, Im Tong-gwōn, Chang Tok-sun and Ch'oe Kil-song, *Han'gugūi p'ungsok I*, Munhwa kongbobu/Munhwajae kwalliguk, Seoul 1970, pp. 111, 117, 119.

15. Cavendish, *Korea and the Sacred White Mountain*, p. 89.

16. Kim Man-hee, *Korean Folklore Pictures*, II, Seoul 1974, pp. 1, 2 and 3.

17. Chang-su Houchins, "'Pōn Ōdo'wa Kim Hong-doūi p'ungsokhwach'ōp" in *Misul charyo* 29, Seoul 1981, pp. 58–61.

18. Otis T. Mason, "Corea by Native Artists" in *Science* VII, no. 183, 1886, pp. 115–117.

19. More artists than those mentioned already worked in the same vein. Very similar, for instance, are the sketches in an album depicting various aspects of the traditional judicial system reproduced in: Sō Il-gyo, *Chosōn wangjo hyōngsa chedōui yōn'gu*, Pakyōng-sa, Seoul 1974, 2nd ed. While the style is slightly different, the subjects—*e.g.* torturing of a suspect,

an execution, a visit to a friend in jail—also occur in the *oeuvre* of Kisan and Sŏkch'ŏn.

20. Nakamura Kinjō, *Chosen fusoku gafu,* Tokyo 1910. Reissued in 1975 by Taejegak, Seoul.

21. Hŏ Yŏng-hwan, "Tongdogŭro kan Chosŏn p'ungmuldo" in *Wŏlgan munhwajae,* 1982. 6, pp. 37–42. Although Hŏ claims that Junker refers to Kisan as being "of Chinese origin", Junker does not make any statement that can be interpreted as such. Hŏ is of the opinion that the handwriting in Korean script on the sketches is not that of the artist himself. As far as I can judge, the handwriting is the same on Kisan sketches from different sources, which makes it rather unlikely that it is not Kisan's own. The material for comparison is limited, however, because many Kisan sketches have captions in Chinese characters.

From the Exhibition of 500 Years of Yi Dynasty Painting

CH'OE SUN-Ŭ

Kim Sŏk-sin's (Ch'owŏn, 1758-?) name has been over-shadowed by that of his more famous elder painters such as Kim Hong-do and Kim Tŭk-sin. But viewed from present-day appreciation, he is an individualistic painter who established his own unique style, different from that of his foster father, Kim Ŭng-hwan, Kim Hong-do and his elder brother Kim Tŭk-sin.

In some way his art of drawing, the technique of brush touch, reminds one of the suggestiveness of that of Chŏng Sŏn; and in what seems his somewhat crude and naive composition his rocky cliffs and rocky mountains catch the shape and mood so common to Korean landscape.

Kim Sŏk-sin was a nephew to Kim Ŭng-hwan who, being without an heir, adopted him, and Tŭk-sin and Yang-sin were his elder brothers. He was born in a family of painters and made himself a painter. When his foster father died, he was 32 and his brother Tŭk-sin was four years senior to him.

Accordingly he was under the great influence of his foster father and brother, and Kim Hong-do who was 13 years older than he, because this famous painter was then under the tutorship of his foster father.

What draws our special attention among the recently known of his works is his picture album, *Tobong-ch'ŏp* of the scenic mountain north of Seoul. Looking into this painting in

which the poetic exuberance overflows from its color, and the speed with which he executed the nimble brush touches, one may well guess his elegance as an artist.

This sensibility demonstrated in his paintings forms the characteristic of his landscapes and at the same time a new world of art Korean landscape painting attained by that time. He had lived long in a family of painters and later served in the government, a sixth grade officer of the military service, but no record concerning his death or his heirs remains this day.

Chŏn Ki (Kolam, 1825-1854) died in the prime of life, at 30. But his talent for painting was such as to move the grand old man of Korean painting and calligraphy, Kim Chŏng-hŭi (Wandang) to write a couplet in praise of his painting in the following words: "His painting shows the new style of Magok, but his poetry retains the old tone of Sŏkpŏm. His poetry and painting are so exquisite that they moved me to write this for him." Chŏn Ki who appealed so much to the appreciative eye of Kim Chŏng-hŭi must have been a distinguished talent who drew the limelight of the art world of the time. However, there is no record concerning his birth, life and art except the

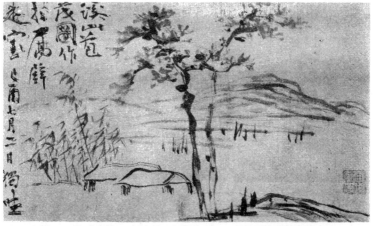

Kyesan P'omudo, 24.5cm × 41.5cm, Collection of the National Museum

Hosan-oesa, by his friend Cho Hŭi-ryong which contains a brief description about the painter:

"He is a man of imposing stature but with distinguished features, and is so full of classic poetry and deep feeling that he looks like a man in the paintings of Tsin and T'ang. Looking into his landscapes shrouded in haze, they are so unique that he realized the secret style of Yüan painting; but the style came out of himself, not from the imitation of Yüan style. His poetry is equally superb. He was able to cultivate his insight and train his brush workmanship because he did not lay the foundation of his art east of the Amnok River (Korea). He died of an illness at his home at the young age of 30."

The above eloquently expresses the regret this old man had over the early death of a talented young artist. There remain some of his landscapes in the style of brushwork called P'amach'u which reminds one of the four great masters of the Southern Chinese School of painting.

The painting entitled "Kyesan P'omudo," a rough sketch in the style of open-minded gentleman's painting, which has the atmosphere of a *literati*, well demonstrates his position as an accomplished poet, calligrapher and painter, one of the best of his remaining works along with his "Ch'ulimdo" in the collection of Son Chae-hyŏng.

His real name was Chae-ryong.

Sim Sa-jŏng was said to have studied under Chŏng Sŏn in his youth but no such trace can be distinguished in his paintings.

Among literature dealing with the systematic appreciation of Sim Sa-jŏng's painting, the preface to this painter's picture album by Kim Chŏng-hŭi merits our attention. In it he wrote:

"Hyŏnje (pen name of Sim Sa-jŏng) started his study of painting from Sim Sŏk-chŏn's method. In the beginning he used the greatly confused dot method which belonged to P'amach'u, or rice-dot method, but in his late years he used the great ax split method. In general, Hyŏnje was well versed

in every subject of painting, but he excelled in the painting of flowers, plants and insects. And next came his paintings of birds and landscape. Accordingly he exerted himself more on landscape painting, and portrait painting was not his strong point. He could not follow Kyŏmje (Chŏng Sŏn) in creating the taste of unrestrainedness and 'dripping wetness,' but he excelled over Kyŏmje in masculinity and exquisiteness."

As Kim Chŏng-hŭi said, Hyŏnje, who admitted his shortcomings as a landscapist, naturally tried harder in his landscape painting. As a result of such hard effort, he left such commanding landscapes as "In Search of a Plum on a Palanquin" and "Passing a Night on a River," and the picture album, "Ch'okchŏndo-gwŏn" which is believed to be a rare masterpiece.

Though small in size his paintings of flowers, insects and birds in deep colors show the maturity and unique style in which no one excelled him during the history of 500 years of Yi painting. It is in recognition of the unique quality of his style that Kim Chŏng-hŭi praised him in such high-sounding words.

The painting reproduced here entitled "Fairies Dancing with Toads" is also a small piece, but in the dancing figures of fairies we may be able to read the image of the artist who has freed himself from the conventional world.

There are some examples among the Yi dynasty portraits that contain simple inscriptions in the regular style of the person painted, his status and name in one corner. However, this portrait of Sŏ Chik-su (1735-1765) is unique in that he describes in running style the history of his portrait and its painters. And there are many more unique aspects in this painting because the man is drawn as a free standing figure with ordinary attire. In composition of the canvas his body is well balanced, and two distinguished painters of the time executed it jointly, Kim Hong-do and Yi Myŏng-gi.

Hamo Sŏnin-do, 22.9cm × 15.7cm,
Collection of the late Mr. Chŏn Hyŏng-p'il

Portrait of Sŏ Chik-su, 148cm × 73cm,
Collection of the National Museum

According to old literature, Sŏ Chik-su was a literatus who passed the first examination for office. His ancestral home was Taegu and his pen name was Sipchukche.

According to his own inscription, his face was drawn by Yi Myŏng-gi (Hwasangwan) and the body by Kim Hong-do (Tanwŏn), hence the superb style. Yi Myŏng-gi was an official painter in the Office of Drawing and son-in-law to Kim Ŭng-hwan, a noted painter of the time and foster father to Kim Sŏk-sin. He was the painter assigned to draw the official portrait of King Chŏngjo. He was no doubt a distinguished portrait painter. And Kim Hong-do who did the body part of the portrait was also noted for his portrait painting. He also did a portrait of King Chŏngjo.

How these two master painters of the royal portrait came to draw this portrait is not known, but Sŏ Chik-su who was ten years senior to Kim Hong-do might be guessed as an

intellectual of the time who was thus honored by these two painters. Another important point this painting reveals is the fact that Sŏ Chik-su wrote this inscription at the age of 62 which tells us that this was executed when Kim Hong-do was 52 years of age.

As one can see, the realistic execution of the dignified face, and the expression of the suppleness of the standing figure with folded hands and the naturalness of attire combine to make this the outstanding portrait of the Yi dynasty period.

There are a few painters of the Yi dynasty period who must be re-evaluated in terms of their position in the history of painting and their style of painting. Among them, Kim Su-ch'ŏl (Puksan, 19th century) comes first, who established his own artistic style, with sensibilities refreshing and full of elegance. In this he was unparalleled. In expressing objects, he did not hesitate to make bold ellipsis and sensible distortions, and his refreshing colorization reminds one of Western watercolors.

All of his paintings of flowers and landscapes are in such a

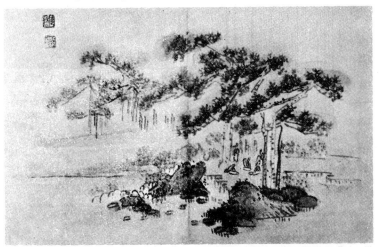

Songgye Handam-do, 33.4cm × 43.3cm, Collection of the late Mr. Chŏn Hyŏng-p'il

vein, but sometimes he made a sketch with a willow charcoal and over it drew outlines and applied colors as if in a single stroke. His unique style comes out of the following: that his paintings are firmly anchored in the elegant taste of the Orient, but in his expressive technique he makes best use of Western skill and sensibilities.

If we trace back the lineage of such paintings, we may find the fact that they have a closer similarity to the landscape of Yun Hong-je and Kim Ch'ang-su, senior painters active during the late 18th and early 19th centuries.

Nothing is known about his family origin and his life, either. But one of his paintings preserved in the museum of Ewha Womans University, a panel of a screen of flower paintings, has an inscription that tells us it was painted in the spring of 1850. And from the fact that some of the landscapes by Chŏn Ki, especially those in the National Museum, have considerable similarity to those of Kim Su-ch'ŏl, Chŏn Ki might have been impressed by those of Kim Su-ch'ŏl.

The painting reproduced here is a panel of landscapes and flowers in the collection of the late Chŏn Hyŏng-p'il, entitled "Leisurely Conversation in the Pine Valley." The distinguished style of the painting tells us that this was drawn in his late years when his art reached the zenith of maturity. The tall pine trees standing along the murmuring stream, the elegance of their dancing branches, and the bold ellipsis in the depiction of figures are the qualities that make this painting one of his most excellent works.

Cho Hŭi-ryong's *Hosan-oesa* contains the above on Kim Hong-do: "Tanwŏn (Kim Hong-do) is a man of delicate demeanor and of straightforward character, and thus like a person living among supernatural beings. He distinguished himself in the painting of landscape, figures, flowers, insects, and birds. But his paintings of supernatural beings are so unique in style that he has no equal." Although he has been

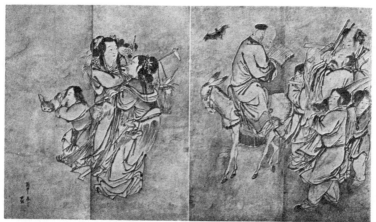

Kunsŏn-do, 48.4cm × 118.7cm, Collection of Yi Pyŏng-ch'ŏl

known in recent times as the great master of genre painting and counted as one of the master landscapists, the above quotation tells us that his special talent was in the drawing of supernatural beings, or fairies.

Reproduced here is the fifth from the left of an eight-panel screen entitled "A Group of Fairies" in the collection of Mr. Yi Pyŏng-ch'ŏl, which is considered the best of his paintings of this category. The composition is unique; the male and female figures of fairies are placed in three groups. The rhythmic sense of movement of each figure and the unworldly demeanor of the figures are features that cannot be achieved by mere skill, but are the gift of nature. The brush manipulation as revealed in the relatively thick monochrome line is adroit without a trace of hesitation, and the speed with which he executed the lines in a single stroke with great nuances is admirable.

He was not only a master painter of fairies, but also an artist who loved nature and justly recognized its amenities. He is also credited with having established a unique style of landscape painting, an eclectic style of which he created by harmonizing the existing Chinese Northern School and the newly-rising Southern School. His exploration of what is

called genre paintings on themes of everyday life of the common people shows another aspect of this virtuoso. The intimate sentiment and humor of the common people as revealed in his genre paintings enables us to see him as a pioneering painter, and in this respect Kim Hong-do as a painter must be reevaluated.

He was born in 1745 but the date of his death is not certain. There are, however, evidences that he might have lived to around 1810 in his paintings. He used various pen names besides Tanwŏn, such as Tangu, Sŏho, Koangŏsa, and Ch'ŏpch'wiong. In his late years he served as the magistrate of the Yŏnp'ung prefecture.

Chŏng Sŏn (1676-1759) used to paint landscapes surrounding the Inwang and Pugak Mountains north of Seoul. There remain many of his paintings of valleys in the present-day Samch'ŏng-dong area, including this "Inwang-jesaekto" in the collection of Mr. Son Chae-hyŏng. These paintings were known as the "Eight Scenes of Chang-dong" and the one reproduced here is also one of them, the largest one of this series ever known so far, which seems to demonstrate the essence of what constitutes the Kyŏmje-style "real" landscape painting, meaning sketched from reality.

The bold composition which fills the entire canvas, leaving hardly any space for the sky, and the peculiar atmosphere thus created by soaring rock formations and the meandering stream with three groups of what look like mountain villas — these combined to make the painting astir with life. From the viewpoint of the man on horseback in the foreground, the high and low rock formations, the graduated terraces which abruptly become steep, the tall pine trees standing on the rocky mountain and other forest trees make this "Valley of Cool Breeze" look more real, and at the same time more sequestered from worldliness.

On the canvas, predominantly monochromatic, dark green

color is applied here and there, but the saddle of a donkey is painted in grass green color, thus making a focal point in the otherwise monochrome painting. Some of his landscape paintings show such focal points.

On the upper right hand corner is affixed his signature which reads that it was painted in the spring of 1738, the 15th year of King Yŏngjo's reign, when he was 63. It is said that he painted in his late years with spectacles one over another. Since he lived 84 years, the period in which he painted this one

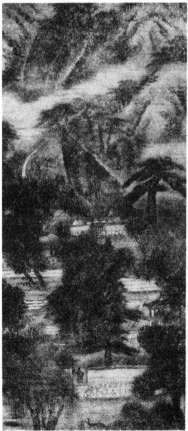 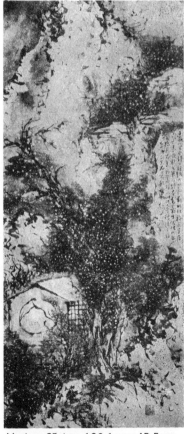

Ch'ŏng P'unggye, 133cm × 58.8cm,
Collection of Mr. Son Chae-hyŏng

Maehwa Sŏok-to, 106.1cm × 45.5 cm,
Collection of the late Mr. Chŏn Hyŏng-p'il

may be said to be the prime of his artistic career. In this respect, "The Valley of Cool Breeze" may be one of his masterpieces longest remembered.

Among Cho Hŭi-ryong's (Ubong, 1797-1859) paintings, the plum paintings show features most characteristic of the painter. In fact, the plum has been his most favorite subject and he left many plum paintings behind. His love of the plum was such he made one of his pen names with the character of plum, the Venerable Plum (Maesu). Especially his paintings of aged plums with cloud-like blossoms on the knotty trunk have qualities that defy imitation.

Well-versed in Ch'usa-style calligraphy, his dynamic brushwork makes each stroke or line of his painting characteristic of the artist. In other words, the quality of his painting pulsates in the subtlety of brush manipulation so peculiar to Ch'usa-style calligraphy.

Kim Sŏk-chun had the following in his poetic remembrance of Ubong: "Ubong excelled in poetry and painting/He's a man of such broad mind that his ideas are distinguished/Following the model of Ch'usa-style, his calligraphy is just beautiful in whatever style he writes." Not only were his thoughts broad and deep, but also he had a complete command over his brush, either in painting or calligraphy.

In fact, he was so well-versed in poetry, calligraphy and painting that looking into his paintings one may discern the meditation of an intellectual and his personal dignity.

The plum painting reproduced here is one of his excellent works in this category. The plum blossoms unfold themselves like rising clouds one after another in the snow. It at first looks completely unrestrained, but on close observation one finds that strokes and lines in monochrome check every element into rhythmic harmony. And in addition, the nuances of monochrome so adroitly handled make this painting delightful.

Ubong used various pen names such as Hosan, Tanno, and

Maesu. His *Hosan-oesa* contains valuable biographies of distinguished painters of his time and some of his excellent calligraphy and orchids in monochrome.

There are not a few painters whose names are buried in oblivion or who were not rightly appreciated even though they left distinguished paintings. In other words, there were many amateur painters, or those who painted as a hobby, and who obscured their unusual talent among the scholar-officials, men of letters and intellectuals in Yi dynasty society.

On the other hand, because they did not want to make their names as painters, they gave their paintings only to their close friends, not many of their paintings came down to posterity to make their names known. This was partly because paintings that deviated from conventionalities or were too strongly individualistic were not correctly appreciated and thus were cast aside. Hong Se-sŏp (Sŏkch'ang, 1832-?) was one of such intellectual painters.

Barely was his name known, and some photographs of his paintings were shown, but they were not critically evaluated.

The painting reproduced here, "Wild Ducks," draws our special attention in that he shows a refreshing sensibility in his use of subtle tones of ink, and his attempt at bold composition which was free from the norms of the time.

In his use of monochrome ink which, however, reminds one of looking at a Western watercolor, one may have a feeling more refreshing than a colored painting. And what makes this painting more unique is its composition; he saw the pair of ducks swimming in a pond as if they were competing in a race from above their head. The layers of waves produced by the advance of the ducks are given expression by undulating zones of different shades of monochrome, which makes the painting more dynamic, and in which we can see the unusualness of this painter's talent.

Hong Se-sŏp, born in 1832, passed the civil service

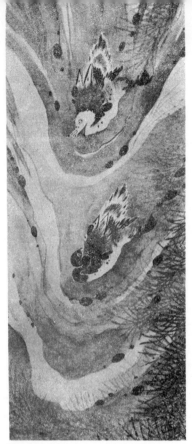

Yaap-to, 119.6cm × 47.6cm,
Collection of the National Museum

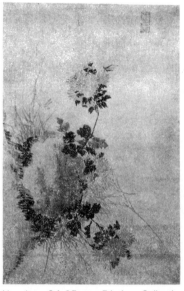

Yaguk-to, 84.65cm × 51.4cm Collection
of the Museum of Tongguk University

examination and was promoted to *Sŭngji,* a third grade officer
at the Royal Secretariat. He was known for his bird paintings,
landscapes and the painting called "cutbranches."

King Chŏngjo is known as a person who loved learning and
arts and as a sovereign who helped bring about a renaissance
during the latter half of the 18th century. Especially he had
a highly appreciative eye for calligraphy and painting,
practicing himself in these arts, and left many unusual works.
 The painting reproduced here, "Wild Chrysanthemum," is
one of the best among his works.
 The lofty and pure disposition emanating from this painting
backs up the fact that it was by the hand of a royal person,

along with the subtle nuances of the smearfree monochrome and the speed with which he executed the powerful lines. His collection of writing, *Hongje-chŏnsŏ* (Hongje was his pen name) contains many references to painting. Kang Se-hwang's influence on the formation of King Chŏngjo's art was thought considerable because he was known for his theories of art and his highly appreciative eye for art, and not only was a favorite official of the king but also encouraged the king's artistic inclination.

King Chŏngjo was born in 1752 as the son of the Crown Prince Changhŏn who was executed in a wooden rice box and posthumously enthroned as Changjo. He died at the age of 49 but he was known as an illustrious monarch who helped bring about the renaissance and who demonstrated a model for the rule of right.

He loved learning and his *Hongje-chŏnsŏ* is a great work which shows his scholastic features. Among his remaining works of painting are counted the "Wild Chrysanthemum" and its companion piece "Plantain," along with his plum painting in monochrome in the collection of the Museum of Seoul National University.

Symbolism in Korean Folk Painting

ZO ZA-YONG

This article sets out to describe the symbolic folk thought behind so-called Korean folk painting. However, it is rather embarrassing to admit that the term "folk painting" has not yet been concretely defined, and the category of folk painting consequently is still not clear. Therefore, this writer will present a classification chart of Korean paintings in order that he may clarify his viewpoint and the extent of the concept of folk painting as applied within this article. (chart I p. 119)

Since the term *Min-hwa* (民畫 *Min-ga* in Japanese, literally means folk painting) was first used by Yanagi-Soetsu, the founder of the Japanese folk art movement, there have been a number of Koreans as well as many Japanese who have made it a habit to apply the Yanagi concept of folk painting directly to Korean popular paintings without any provisions. Thus, they inclined to select only the articles under low folk painting to match Japanese *Min-ga* and European peasant paintings.

As one expands his selection of Korean folk paintings further he will soon run into more sophisticated examples which are still anonymous, practical and symbolic just as the low peasant paintings were. At this point he will be asking himself whether or not such refined examples should be excluded from the sphere of folk painting.

Hereafter he will gradually begin to realize the different status of Japanese *Min-ga* and Korean *Min-hwa*, and the difference in concept of "folk" itself. Having learned the historical background that the literati scorned a large number

96

of Korean utilitarian paintings as folksy products one may be led to embrace those abandoned paintings with a positive attitude and to treat them as decent works of art. They should be viewed from the standpoints of folklore, symbolism, function, popularity, ethnology and aesthetics.

When Korean paintings are viewed with the eyes of symbolic art the extent may cover practically all paintings shown in the chart, for every religious painting is based on its religious symbols, and classical paintings and court paintings contain plenty of folksy symbolic themes, just as we find classical themes in folk painting. This article, however, will limit its scope to household paintings, for they really constitute the central core of Korean folk painting.

The Religious Background

"What does this painting mean?" This simple query is the unspoken first question which most people ask when they come across an unfamiliar work. Man or woman, old or young, high or low, educated or uneducated, all ordinary folk tend to approach works of art from the point of view of practical symbols of good meaning which a particular work can add to everyday life. Really this is the world of folk painting where every piece of work is supposed to contain some symbolic meaning. Painting, unlike food, shelter and clothing, is not a biological essential for man, but more of a cultural luxury product. Thus thought behind painting, whether of an academic nature or a folksy character, must be taken as important cultural expressions of mankind.

In the study of Korean culture we have made it a habit to treat Confucianism, Taoism, Buddhism and Shamanism as the religious thought behind art. Naturally, when we try to classify Korean folk painting we first attempt to sort them out according to those religious thoughts. As a matter of fact, such classifications are valid only to the extent that some typical

themes have clear religious identification. For instance, we start by taking the Buddha's life themes as Buddhist painting, Taoist immortals as Taoist painting, illustrations of Confucian teachings as Confucian painting, and the Mountain Spirit with tiger as Shamanist painting. However, we soon encounter a strange phenomenon; all of these religious thoughts are interwoven so complexly that we get lost as to which specific religion each belongs. Anyone who visits Korean Buddhist temples will easily find the Seven Star Spirit painting. Is this Buddhist, Taoist or Shamanist? It is not a simple question to answer. We may discover extremely Taoist expressions in Mountain Spirit paintings, Tok sŏn and Nahan, all of which are housed in Buddhist temples. Are these Buddhist or Taoist paintings? After having experienced this, we end up with the impression that in Korea there is Taoistic Buddhism, Buddhistic Shamanism and Taoistic Shamanism. Indeed, this is the very key to a proper understanding of Korean folk painting, for all of these religions have contributed to popular art's development, because everyone has participated regardless of specific religious identification. Since all of these religions stand as the background thought for various paintings, we shall briefly outline each one and its resultant art. From there on we shall dig out the common symbolic denominator which interlocks these religious thoughts and folk paintings tightly together enabling them to live under one roof in Korea.

Buddhism and Korean Folk Painting

According to standard histories Sakyamuni was born in 566 B.C. and died in 486 B.C. Two hundred years after his death King Asoka spread his teaching, so Buddhism came to China after having spent five hundred years in India. It took three hundred more years in China before it was transmitted to Korea where another two centuries intervened before it was

sent over to Japan.

The advent of Buddhism in each country must have meant the arrival of Buddhist scriptures, sari and sculpture, which means both the theoretical and popular side of Buddhism came together. From the standpoint of sophisticated Buddhist philosophy how ridiculous to be building huge pagodas over Buddha's bones for direct worship. Yet we must remember that the art of Buddhist pagodas was born from such ridiculous behavior by believers, The point asserts itself that it is the folksy shamanistic portion of Buddhism that creates Buddhist art, not its scholarly side.

"Believe in Buddha and receive good fortune." This is the way Buddhism was advocated when it came to the Paekche Kingdom in 384 A.D., just as modern Christian evangelists spread their doctrine by loudly proclaiming "Believe in Jesus and go to Heaven." The first monk who came to Silla was successful in his evangelism by curing the desperately-sick princess through a miraculous incense burning ceremony. Buddha, in his wisdom, explained the truth of life in terms of elevated principles and deep philosophy to those who could understand; those who were simpler he taught by amusing folk tales or parables. According to the scriptures, through his divine power Buddha performed miracles. He cured fatal diseases and conquered evil spirits. He stopped the waters of rivers and traveled to Heaven and to the dragon palace. Like any other organized religion Buddhism has two parts, one the theoretical, and the other a believing part expressed in terms of worship. For convenience let us call the theoretical part Buddhi-Academism and the believing part Buddhi-Shaman-ism.

The strength of a religion is not in knowledge but in belief. In fact, the ignorant but pure devotion of the Buddhi-Shamanistic believers forms the strength of Buddhism, and this devotion is what we see expressed in Buddhist art, the wordless scripture of the people's faith. The reason that Buddhism was acceptable to ancient Korea was not only

because Buddhi-Shamanism had something in common with Korea's own Shamanism but created miracles that brought good fortune as well as repelling evil spirits. Furthermore Buddhi-Shamanism brought art forms such as pagodas, temple bells, paintings, sculpture and other paraphernalia to improve the religious environment.

Let us now try to evaluate the substance of both sides of Buddhism reflected in Korean painting. The academic side contributed rather indirectly by reflection of its ideals in artistic expression such as accomplished in Zen painting, while the shamanistic side developed extensive ritual painting directly from Buddhist symbols. In order to worship Buddha they created and painted an ideal image of a graceful Buddha; they invented imaginary scenes of Buddha's pre-life as well as his earthly life. They developed specific paintings of the Buddhist paradise as well as hell scenes for common worshippers. The story of Buddha tells us that he meditated for six

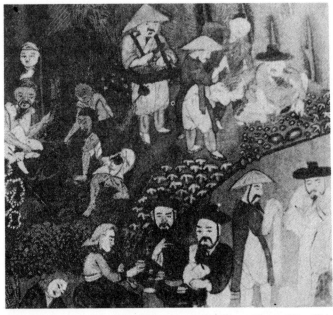

This picture is a partial detail of a huge scroll of *Kamro T'aeng Wha* (The scroll of sweet Dew), in which Korean life style is incorporated with the Buddhist teaching.

years so intensively that he did not realize that birds were nesting on his head. However, when they refined the image of a sitting Buddha in art forms, they dressed him with a golden veil, snail hair style, and even applied lipstick, all for the propagation of popular Buddhism. As a result, this form of symbolic art was accepted all over the Orient.

The Buddhist ritual paintings, called *t'aeng hwa* in Korean, are usually mounted in two different styles, one in the form of a scroll and the other in the form of a panel with heavy iron fittings for installation. Beside these standard ritual paintings there exist what are called "Side Paintings" and "Miscellaneous Paintings" which are attached to walls, ceilings, eaves and pillars. The themes for side paintings include not only popular Buddhist legends but also common Korean folk themes such as used in domestic painting.

As far as domestic folk painting is concerned Buddhist painting contributed very little, for most of the Buddhist symbols were strictly limited to use within temple buildings. However, there is an art of woodblock printing which Buddhi-Shamanism contributed to Korean households. It is known as pujŏk, paper amulets of Buddhist origin, which even today are sold at various temples and stores. These Buddhist pujŏk, just as the Taoist pujŏk and Shamanist pujŏk, are directed to inviting happiness and repelling evil spirits by application of numerous Buddhistic symbols such as the Buddha's footprints, pagoda, Kwan-ŭm, various Buddhist guardian images, magic characters and designs.

Taoism and Korean Folk Painting

It is commonly understood that there are about four thousand Buddhist temples of various sizes standing all over Korea while not a single Taoist temple is known today. In spite of the fact that Taoism actually has a closer relationship with folk life than Buddhism very little is known or spoken of

Korean art in terms of Taoism. In fact, very few Koreans would know what Taoism is, what Taoism believes, who founded Taoism, or what a Taoist temple is like. In Korea Taoism does not function independently but it does exist by being compounded with Buddhism and more particularly with Korean Shamanism. Without self identification Taoism somehow has penetrated into Korean homes with its symbolic art, while Buddhist paintings have not been able to break out from the temples. Therefore, we need to understand at least the outline of Taoism and its relationship with Buddhism and Shamanism in order to properly appreciate Korean folk painting.

Usually we treat Sakyamuni as the founder of Buddhism although it was King Asoka and his followers who organized Buddhism as a religion. Likewise, we consider Lao Tze as the founder of Taoism while it was Chang Tao Ling of the Han dynasty who started Taoism as a popular religion. Few biographical details are known about Lao Tze, for unlike the Confucian scholars who led active lives on the political stage, Taoists traditionally lived the life of a hermit. Among the few facts that we do know about Lao Tze are his name (Lee Erh), his sobriquet (Tan), and his birthplace (the state of Chu). Born some twenty years before Confucius, around 570 B.C., a time when the Chu state in the southern part of China was notably progressive, Lao Tze lived in a stimulating intellectual climate and served as the director of the National Library for the state of Chou. His teaching is contained in a 5,000 word classic, Tao Te Ching, which advocates a return to the natural, simple life. At the end of his life rumour has it that Lao Tze vanished into the vast deserts of western China, thus disappearing from mortal view by becoming an immortal.

The ancient Chinese Taoists strongly believed that Lao Tze who became an immortal after his death would reincarnate every generation taking different forms. Since the year of the birth of Sakyamuni practically coincided with that of Lao Tze and much of Buddha's philosophy agrees with Lao Tze

philosophy, there was perhaps good reason for Chinese Taoist scholars to believe it was Lao Tze who reincarnated in India, taking Buddha form. We can physically visualize this effect by examining Korean Buddhist paintings in which most figures are dressed in Taoist costumes rather than Indian veils. During the late Han dynasty in China, a man named Chang Tao Ling founded the religion of popular Taoism. Through years of self cultivation in China's deep mountains he was enlightened, and attained a magic power to heal diseases which in turn fascinated his followers. The multitude followed him by practicing Taoist Yoga and searching for immortal food to induce long life. Chang must have realized that every religion is a compound of two elements, philosophy and folk faith, without which it can not survive, for in founding his church he combined the philosophy of Tao set down by Lao Tze with primitive folk faith of long life and all the beliefs that go with it. Chang named the new religion the "Five Bags of Rice Church," for any man could join simply by donating five bags of rice, but the religion has since been known as Taoism.

The Taoists believe in God, calling him "The Jade Emperor of Heaven" who takes two other spiritual forms, Nogun and Togun, when appearing in the world. Nogun is often taken as the image of Lao Tze and, interestingly enough, he is also taken as Buddha. As far as the devotion of believers goes the worship of this trinity of deities is the very center of Taoism. Consequently the portrait painting of the three deities with the portrait of Chang Tao Ling is the very top ritual painting in Taoist art.

Popular Taoism includes worship of the North Star, the Big Dipper, site spirit, the spirit of fortune, gate spirits, the longevity star, and numerous other immortals as well as the principle of Yin-Yang and shamanistic ecstasy. It is obvious that most of the components of Taoism did not start with Chang Tao Ling but had existed with the old Shamanism. It may be taken as the merit of Chang that he so marvelously took various shamanistic elements and systematized them into

an organized religion.

Just as we named the folksy side of Buddhism as Buddhi-Shamanism, let us now call the primitive side of Taoism Tao-Shamanism, and see how Tao-Academism and Tao-Shamanism are reflected. In Korean painting, typical Taoist figures such as paintings of immortals and the Longevity star spirit were put together with Buddhist Nahan or Bodhidharma paintings and they were all named and housed under one unified theme of Tao and Buddhist painting, which occupies a distinguished position in orthodox Oriental painting. Moreover the most significant contribution that Taoism made to Oriental painting is its philosophical reflection which has produced the unique art of Zen and literati painting by use of simple ink alone. Thus the academic portions of both Buddhism and Taoism were unified under an academic Oriental painting.

On the other hand Tao-Shamanism created various ritual paintings of its own, such as the images of three spirits, various star spirits, and numerous guardian images believed in by the Taoists. Much Taoist ritual art is indebted to Buddhist art as we see in the details of Taoist gods apparently copied from the Buddhist style. Such paintings, a few samples are shown here, are seldom seen in Korea, for there is no independent Taoist shrine where Koreans worship Taoist gods, except a few Kwan Ti shrines equipped with a limited number of Taoist paintings.

Although ritual paintings are rare, Taoist taste is found in court paintings as well as Korean domestic folk painting. Large screens such as the ten longevity symbols, the sun and moon screen, the celebration of a fortunate life are the most typical Taoist themes along with others directly copied from the Chinese.

Taking into account that folk art is interwoven with many different religious art forms it is not easy to sort out purely Taoist art from Korean folk painting. However, certain typical elements may be found in the fungus of immortality

(*pulloch'o*), the peach of immortality, the bottle-gourd of immortality, all of which are believed to be Taoist in origin. They are usually combined with deer, crane and various Taoist immortals.

Let us now turn our attention to the symbols of love. It seems rather puzzling to most modern men that none of the five components of Oriental happiness included "love." We may try to interpret that conjugal bliss was included in "love of virtue," but we still do not find substantial evidences to verify such an assumption especially in view of the fact that there are so many materials on love of children, filial piety, ancestor worship and loyalty to the King.

Since we do not find clear identification of conjugal affection under a particular theme of painting let us now carefully examine domestic picture screens and see if there is any indirect expression of love. It has been widely understood that the screens of flowers and birds were the most popular

This picture shows Surion or the south pole star spirit which is a popular painting of Taoistic origin.

works of art which used to be placed at wedding ceremonies and bedrooms. More specifically, the Mandarin ducks, wild ducks, or geese were treated as the most virtuous loving birds, for these birds neither divorce nor remarry. As a matter of fact we find countless wooden ducks which were used in old Korean homes as the symbol of wedding.

Looking at these screens more carefully, we will soon discover the fascinating fact that birds are painted in pairs to symbolize a loving couple. Usually we find a pair of birds asleep side by side on a branch, a pair flying together in the sky or swimming in a lotus pond. Often we come across a painting showing the scene of kissing birds or even love-making birds. This principle is also true in animal and fish paintings. Moreover, we often run into paintings where even trees and flowers are painted in a pair.

Thus, love was not treated as an artificial virtue but as a natural phenomenon of Yin and Yang just like the movement of sun and moon or night and day. As Oriental philosophy explains nature as the creation of Yin and Yang the symbols of love in painting were expressed by love of nature itself. Consequently we must take this expression as an expression of Taoist philosophy, for it was the Taoists who developed extensive household art full of references to sex and sexual customs.

Confucianism and Korean Folk Painting

The Orient's three great sages were all born about the same period according to tradition (Lao Tze in 570 B.C., Confucius in 552 B.C., and Sakyamuni 566 B.C.). Their philosophy, teaching, and belief are supposed to be different, but in studying Korean folk painting it seems more important to strive for discerning the common elements rather than emphasizing differences.

Because Confucianism, from an academic standpoint, has

been treated as a social ethic, the religious side of Confucianism has been ignored or underestimated. It was clearly written that Confucius stressed rationalism and condemned irrational superstitious folk belief. As a result no one prays to Confucius or asks him to grant good fortune or miracles to cure diseases as they do in Buddhist temples or Taoist shrines. Why then do people treat Confucianism as the dominating Oriental religion? There must be hidden religious elements in Confucianism other than the acknowledged dignifying teachings on personal relationships. According to the formula that every religion is composed of a philosophical portion and a devotional portion, let us divide Confucianism into Confucian-Academism and Confucian-Shamanism, although Confucius himself would not be pleased to hear this new term.

If we carefully observe the behavior of Korean people it becomes obvious that Koreans are still living in the mode of a Confucian way of life following classical social etiquette and standards of ethics. This portion does not contain much of a religious element, but if we examine Confucian funeral services or a family ritual for ancestor worship, it is certainly a religious ritual where all sorts of symbolic folk art decorate the environment. In the old days each family had a house shrine or Hon Back where the ancestral spirits were supposed to dwell. After a burial service, (after the physical body was covered up beneath the ground) the family mentally transferred the spirit into this small paper shrine and brought it back to the house. On each memorial day the entire family assembled for a ritual, usually hanging up portrait paintings or a unique type of scroll called Kammo Yoje-do.

The most conclusive fact about extant Confucian-Shamanism is that Confucius himself believed in "Heaven," "The Heavenly Way," the principle of "Change," and he accepted the I-Ching, or "The Book of Changes." Of course Confucius endeavored to maintain his scholarship despite these beliefs, but soon many of his followers exposed their

inborn naive belief, taking the principle of "Change" as the magic basis of fortune telling. Furthermore it is because of the existence of Confucian-Shamanism that such a thing as "Confucian folk painting" can be thought of along with Taoist and Buddhist folk paintings.

It is through this belief in "changes" or luck that Taoism and Confucianism share something in common. In a way the I-Ching unites all three religions in Korea. There is no such person as a purely Buddhist monk any more than there is a purely Taoist sage or a purely Confucian scholar. If we denote for convenience Taoism as T, Buddhism as B, Confucianism as C, and treat them as chemical elements we may be able to express the typical Buddhist monk with the formula of $B_{10}T_5C_3$, the Taoist sage as $T_{10}B_1C_2$ and an average Confucian scholar as $C_{10}T_2B_2$. Therefore when we refer to Confucian painters of the Yi dynasty, we mean those literati painters who

This picture, taken from the 18th century book of filial piety, illustrates a loyal son catching a huge carp in the winter for his ill mother.

lived in a Confucian mode, upholding Taoistic and Buddhistic ideals and reflecting them in their art. Here again we observe the phenomenon that the academic sides of all religion become united through literati art.

Just as Taoism and Buddhism furnished certain classic themes for Oriental painting, Confucianism too furnished its own symbols, such as a portrait of Confucius, the nine turns of Mui, the gathering at Lan Ti, and the nine turns of Kosan. However, compared to Taoist and Buddhist themes, Confucian ones are relatively rare. It is interesting to realize that during the Yi dynasty when Confucianism became the official religion, the literati painters or Confucian-oriented painters developed so few themes on their own.

In folk painting too Confucianism brought hardly any themes of its own origin. Probably it lacked the mystery element of most folk beliefs. Nevertheless, Korea has preserved some unique folk art which may be referred to as "Confucian folk painting." The eight-character screen manifesting Confucian virtue and the screen of "a book pile scene" are two of these themes which have almost been forgotten until recent years. The screen of filial devotion, an educational illustrative painting should be recognized as a self explanatory Confucian folk painting that was popularly used in the home for children's edification.

Let us now explore the world of folksy happiness symbols again, and see how Confucian people treated this matter. We find various interpretations of happiness not only within the world of folk art but also in classical literature. The following are some of the well-known Oriental concepts of the five components of happiness.

(A) 1. Long life
2. Wealth
3. Peace and health
4. Love of virtue
5. Peaceful death
(B) 1. Long life

 2. Wealth
 3. Health
 4. Freedom from misfortune
 5. Virtue
(C) 1. Long life
 2. Wealth
 3. Nobility
 4. Peace and health
 5. Fertility

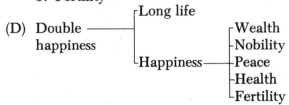

(D) Double happiness — Long life / Happiness — Wealth, Nobility, Peace, Health, Fertility

Obviously the scholars of olden days did not neglect the importance of the fundamentals of life, but they generously tolerated the basic desire for a happy life by providing such interpretations. This tolerant attitude of the elites to popular symbolism, contrary to our usual understanding of the literati group's scornful attitude, seeded folksy elements in classical paintings as well as seeding classical elements in folk art. Very often we encounter classical paintings with such folksy themes as "long life as pine and crane" or "mountain of longevity, ocean of good fortune." On the other hand, we are confused by so many naive landscape paintings in folk art in which the symbolism is vague.

As we go along with the classical translation of "happiness" we may go ahead and include those themes, such as filial piety, the eight virtuous characters, and book pile scenes related to virtue as one of the five major components of happiness, which were contributed by Confucianism.

Shamanism and Korean Folk Painting

It has been explained that the leading religions of Oriental

society are all related to a belief in "changes" one way or the other. And we have shown that this "Change" belief is composed of an academic element as well as a magic element. Indeed, the principle of "Change" was thè oldest Eastern wisdom originally conceived and developed by shamans, largely being used in fortune telling. It is one principle that has never been neglected by any Oriental including Emperor Hsih Huang Ti who burnt all academic books but saved "The Book of Changes." As has been observed, the great shaman wisdom was never neglected, but was taken by Confucian and Taoist scholars for academic development. We have been using rather unfamiliar new terms such as Buddhi-Shamanism, Confucian-Shamanism to designate the folksy side of each religion. Finally, we have now arrived at the stage where we must discuss orthodox Shamanism which was uncontaminated by academism but remained in its original form.

After considerable field study and research it becomes apparent that there is no such thing as pure Shamanism, but rather the compounded Shamanism of Buddhi-Shamanism, Tao-Shamanism and Confucian-Shamanism. Apparently the *mudang* ritual remains the only unchanging characteristic of original Korean Shamanism. However, if we carefully observe the behavior of *mudangs*, study ritual paintings and sculptural objects in the *mudang's* house, and the words of ritual songs, we end up with the conclusion that there is so much variety that it seems that the original rituals have been obscured.

Just as the *mudang's* house is filled with Buddhist elements the Buddhist temple is dressed with Shamanist elements. Before we enter the first gate of a typical Korean Buddhist temple, there stand two guardian posts made of an old tree trunk with its roots remaining to suggest hair, and with big eyes in a dignifying powerful gesture, but with a gracious smile at the same time. Is it a Shaman, Buddhist, or Taoist smile? Or is it possibly a Confucian smile? Generally it is agreed that the Korean guardian post (called Chang Sŭng) is of shaman origin. However, we find them at the entrance to

Buddhist temples as well as at village entrances.

The first gate we must go through is called Ilchu-mun, literally meaning "one post gate." This signifies a gate with poles in a single row. If we recall the Japanese Shinto shrine gate or torii and put a simple tile roof on it, it becomes the Ilchu-mun. Is this Buddhist in origin or Korean Shindo? The next gate is the gate of four Buddhist guardians of which the origin is no doubt Indian Buddhi-Shamanism. However, looking at the statues and paintings carefully there exists a very· strong Tao-Shamanistic impression. This effect is repeated at the next gate, that of Buddhist giants, then the Golden Hall, Nahan Hall, the Funeral Hall and such other buildings as exist. As a rule in Korean temples behind the Golden Hall we find three charming side shrines—the Seven Star Shrine (Ch'il-sŏng-kak), the Mountain Spirit Shrine (Sanshin-kak), and the Tok Sŏn Spirit Shrine. For every variant of Shamanist belief in star spirits, we experience a compound of different forms of Shamanism at the tiny Shrine of the Seven Star Spirit.

In the next shrine we find a graceful old man with an affectionate smile sitting with a friendly tiger. He's the mountain spirit! According to old records it was more than four thousand years ago that Tan'gun, the national founder of Korea died and became the "mountain spirit." Whoever takes this record seriously will be surprised to find the long historical flow traced through this unique religious painting. Furthermore, Korean shaman, or *mudang*, use this painting as the very epitome of their central belief. However, studying through religious paintings we discover that some of the Nahan paintings of Buddhism and Taoist immortals also have a similar character riding a tiger such as in the Mountain Spirit paintings. We get lost as to the origin of this fascinating religious painting because of the vague division of lines between Taoism and Shamanism, between Buddhism and Shamanism.

Finally let us peek into the next cozy shrine of a Buddhist temple, called Toksŏn-kak. There we find one other old man

who looks rather lonesome and somewhat indifferent surrounded by the fungus of immortality, pine, rock, water, cloud, crane, and turtle. All these always are taken as Taoist longevity symbols. Moreover, Tok sŏn is a typical Taoist philosophical term based on Lao Tze teaching, meaning "self-cultivation." If the old man only smiles he will no doubt be taken as Su Ro, the Southern Star Spirit of longevity originated by the Taoists. However, Buddhist monks insist that Tok sŏn is also called intimately by the believers Na Ban, the first man supposedly descended from the heavenly world in Korean mythology. After all these three shrines are still called Sam-sŏng-kak or "the shrines of the three spirits," which from its title matches perfectly with the old Korean Shindo shrine in which three national deities (Hwan In, Hwan Ung, and

This illustration is the mountain spirit with a tiger beside him.

Tan'gun) are worshipped. Whoever has come this far may become so fascinated as to visit hundreds of these trinity shrines all over Korea. After such investigation he will probably come to the conclusion that the central image in the Seven Star Spirits is Buddhistic, the old man with a tiger in Mountain Spirit shrines is shaman and the angry old man in a Tok sŏn shrine is a dominant Taoist. This means that there exists a certain uniform distribution of the three denominations of Korean Shamanism within temples that are commonly treated by people as Buddhist temples. As far as the paintings evidence Korean temples are Buddhi-Tao-Shamanist worship centers. This is backed by the traditional Koː an folk term for temple (*Chŏlgan*), which simply means "a place where we bow."

When religions are viewed through the eyes and mind of a Shamanist believer they are no more than denominations of the original Shamanism. What then is the nature of the supposed original Korean Shamanism? Before this question is answered it may be more proper to ask what the original common Oriental Shamanism was like prior to bringing Korean ethnic elements into question. Briefly Oriental Shamanism is the primitive religion believing in a heavenly spirit, spirits of sun, moon, stars, earth, mountain, water, rock, tree, ancestor, warriors, and ghosts. It has faith in the magico-religious power of human shamans who in states of ecstasy are capable of communicating with various spirits. It accepts the principle of Yin and Yang which governs universal movements including human destiny. To these universal beliefs of Shamanism the Korean branch adds worship of their own national founder Tan'gun and spirits of various other national figures. What sort of role did Shamanism play in Korean folk painting? Not only to folk painting but also to orthodox Oriental painting Shamanism contributed a distinguished spiritual element which is generally known as "animism." Because of academic bias which scorns animism as "a primitive, superstitious belief," the importance of animism in

art forms has been underestimated. In Oriental landscape (particularly rock) painting animism is a far more important spiritual element than Taoist naturalism or Buddhist Zen concepts. In folk painting animism is more positively and explicitly expressed through forms of fantasy and abstractions.

When we talk about Shamanist painting we generally refer to the ritual paintings used in a *mudang* house. Such include the spirit of sun and moon, the seven star spirit, the spirit of five directions, the twelve zodiac spirits, the heavenly spirit, the jade emperor, the Mama spirit, the Aegi spirit, the thunder spirit, the white horse general, the dragon spirit, the mountain spirit, the three spirits, the three Buddhas, the Indra spirit, the Kwan Ti spirit, the spirit of General Lim, the spirit of General Choe, the spirit of monks, the spirit of *mudang*. Here Again we discover various combinations of Buddhi-Shamanism, Tao-Shamanism, and Orthodox Shamanism.

Because it is a general rule that no religious ritual paintings are allowed into private places, no shaman ritual paintings were used in Korean homes. However, our houses were filled in past centuries with folk paintings of shamanistic derivation such as the symbolic pictures of long life, good luck, and evil-repelling. People believed positively that a dragon or carp dream would result in a boy baby. They knew that placement of a one-hundred-baby screen in their bedroom would expedite pregnancy or that tiger and rooster paintings pasted on the front door would chase evil spirits away. Charming domestic folk paintings resulted from these deeply-ingrained beliefs.

The Ultra Belief

In the study of the symbolic aspect of Korean folk painting it is a matter of the utmost importance to get a proper picture of each component religion and its relationship. To assist in understanding a diagram is presented to illustrate the

relationship of each religion in Korea. Basically the two concentric circles represent the spheres of Shamanism and Academism which Korea's three major religions (Buddhism, Taoism, and Confucianism) occupy to form the spiritual heart of Korea. In the sphere of academism each religion occupies a certain portion named Buddhi-Academism, Tao-Academism, and Confucian-Academism respectively. Although each strives to identify its independence none can exist isolated but each has a certain area which it shares with the other two. In the sphere of Shamanism they are named Buddhi-Shamanism, Tao-Shamanism, and Confucian-Shamanism respectively, with closer and larger relationships with the other two. Theoretical mother-Shamanism on the other hand contains all three elements in her body, with the original element gradually shrinking along with growth of the three denominations.

In the sphere of Academism, Buddha preached the Diamond Sutra, Lao Tze spoke of the principles of Tao, and Confucius taught the theory of change. Today in the sphere of Shamanism Kwan Ŭm (Kwan-Yin) still delivers Buddhist miracles, the South Pole Star brings Taoist long life, and the Confucian tigers reward devoted children, while Santa Claus delivers Christmas gifts to Korean Christians. If the sphere of Academism is where people argue, then the sphere of Shamanism is where people believe, pray and worship symbolism. From the standpoint of the sophisticated side of religion how ridiculous to believe in such primitive symbolism. Yet we must remember that it is the folksy side of religion that creates religious art.

By removing the various masks that men wear in the sphere of Shamanism we can move one other step forward and there we end up with a common ultimate belief which belongs to every man on the earth. This common faith is named here as "the Ultra Belief," implying inborn desire for a long and happy life, a successful fight against evil spirits, and self-motivated prayer. The central core area in the diagram is

where all men begin their life by eating, sleeping and discharging. Let us for convenience call the human being at this destination "ultra man," differentiated from primitive man, for ultra man is applicable to everyone beyond time and space. Let us now try to visualize the world of ultra men through careful observation of our daily life.

"With this cup of wine go best wishes for your long life!" In olden days Korean people used to begin their wine parties with this short "Wine-offering song," sung by *kisaeng* girls. Indeed wine was drunk for a longlife tonic, not just as intoxicating alcohol. "I wish you long life!" We Koreans today still greet older persons with this simple expression, and we live, no matter how poor or westernized we are, with a conscious respect for aged people. Even today's television shows often include the old age celebration where country folk are invited to reveal their feelings to the public on reaching these goals. Of course no one is contented merely with the number of years but also seeks quality as well as quantity, of happiness.

Ethnic Symbols

As was already mentioned briefly the central thought behind Korean folk painting was not ethnical symbolism but was the very basic universal human desire for happy life. However, as we deal with these popular works of art which are so closely linked with Korean folklore, we cannot help viewing the ethnic aspect of these paintings.

First of all, Korean genre paintings and landscapes of native scenes should be mentioned, for these two groups were recognized not only in the field of folk painting but also in classical painting. Such prominent artists as Tan Wŏn, Hye Wŏn and Kyŏm Je played leading roles in creation of these paintings of ethnic significance.

The typical Korean landscape painting includes such pictures of ethnic scenes as "The Eight Scenes of Kwan-dong,"

"The Map Style Landscape of P'yŏng-yang," "The Nine Turns of Kosan," "The Ten Scenes of Cheju Island," and "The Diamond Mountain." Of these the Diamond Mountain painting is probably the most significant creation ever made by Korean artists.

Realizing the fact that Korea possesses the Diamond Mountain, a mountain whose beauty can never be imagined in human dreams, they developed a unique landscape painting of their own, based on the actual form of their holy mountain. They simply didn't need to borrow either the Buddhist or Taoist dream to express the ideal beauty of nature. All they had to do was to sketch the natural beauty of their own Diamond Mountain, which already possessed all of the Buddhistic and Taoistic ideals. Looking over a number of albums which are preserved today, we can easily visualize the old Korean painters hurrying to the Diamond Mountain with their sketch books. Nevertheless, no realistic sketch could successfully express the true mysterious beauty of the holy mountain. So, these painters ended up with a unique crystal shape abstract landscape painting. This style was more enjoyed by the nameless painters who created fantastic folk paintings of the Diamond Mountain. Quite often we come across paintings that look like kindergarten paintings or comic strips. Although their brush lines are native, they are all enjoyable because we feel our own life in them. In folk paintings of the Diamond Mountain we find the genuine expression of animism and creative style. The peasant's free style art, ignoring all the strict rules and standards, must have played a significant role in developing the unique ethnic art of Diamond Mountain painting. Along with these landscape paintings of ethnic scenes there have been developed a number of domestic paintings which are unique enough to be labelled as Korean ethnographic paintings. First of all, the traditional icon paintings of national ancestors and the ancestors of each household are worthy of mention. Interesting enough such portrait paintings, which were primarily utilitarian art, have

been recognized by modern art historians as classical iconographic painting with distinct characteristics.

The next examples are those which have been known as historic record paintings. This includes the pictorial presentation of various parades, all kinds of court rituals, royal hunting scenes and even war scenes. The best known example among these is probably the screen of the turtle ship fleet. In the 16th century when the Japanese invaded Korea, Admiral Yi Sun-shin, appointed as the commander of the united fleet, created the unique battle ship known to the world as "turtle ship." There are several folk paintings of each individual turtle ship itself, as well as of the fleet formation in which many turtle ships are shown.

There are also a number of ethnic guardian paintings, including the Korean tiger and other popular images which were already treated under evil repelling symbols. Such ethnic religious paintings as mountain spirit, water spirit, and shamanistic guardian paintings really manifest ethnic

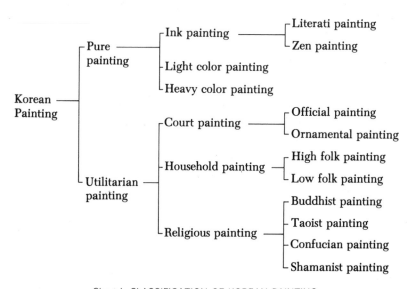

Chart I. CLASSIFICATION OF KOREAN PAINTING

characteristics. However, these paintings were not used in the household but exclusively used in Buddhist temples and shaman centers. With the exception of these unusual ethnic themes, all other symbolic figures are actually common to all the Oriental people, and, furthermore, the dominating central theme is no other than the universal human desire for happiness. Nevertheless, an important conclusion may be drawn at the very point that Korean folk in olden days succeeded in creation of the most extensive and refined folk paintings for everyday life based on such naive folk symbolism.

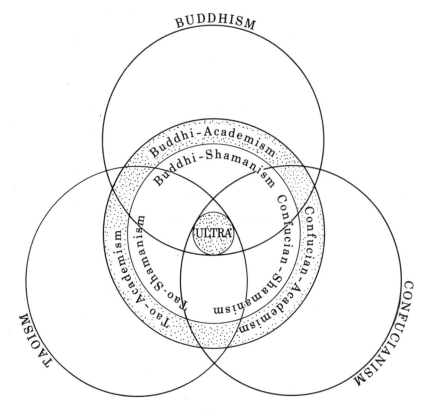

YU-BUL-SŎN DIAGRAM

Folk Painting and Folk Aesthetics

ZO ZA-YONG

Korean Aesthetic Terms

It has been stressed that Korean folk painting was produced neither as "art for art's sake," nor developed according to any formula of theoretical aesthetics. Perhaps an overemphasis on this point may lead to the impression that these paintings totally ignored any principle of aesthetics. However, it is in this very folk art field that we find distinctly national characteristics, some of them less readily discernible in the so-called fine arts. If anyone digs deeply into Korean art, he will find that there exist unwritten aesthetics throughout the history of all its art forms, but folk painting reveals it very clearly. Confucian scholars blindly repeat the words of "The Six Canons" of Oriental painting established by the sixth century China as their aesthetic standards; Korean country folk will just as stubbornly argue about "white" when they look at the tone of whiteness of a fabric, mulberry paper, rubber shoes, or even rice cakes, all this based on their keen, inborn sensitivity for white color. Whether it is snow-white, milk-white, pearly-white or cotton-white is a matter of great concern to them. Similarly there are hundreds of different tones of green-blue from which the mysterious Koryŏ jade green was discovered. The natural, unpretentious ruggedness so unconsciously manifested by old Korean craftsmen in architecture, ceramics, papers and hemp was sensed long ago by Japanese tea masters who after considerable struggle finally were satisfied in their standard of ruggedness by the Korean teabowls of the six-

teenth century.

Korean folk painting need not be separated from other art forms; it meets the standard taste of traditional Korean art at large. Therefore we must try to formulate the criteria of Korean folk aesthetics which underlie all portions of Korea's traditional art. Let us examine a few examples of Korean aesthetic terms which are practically impossible to interpret literally in any other language, and try to appreciate the illustrations in this article, keeping in mind these unique words of praise or of appreciation which the "unknown artists" who created folk art understood intuitively.

Mŏt (멋)

If a Korean is asked "What is art?" he might reply "Art is an expression of *mŏt.*" Indeed, the highest term used in everyday life, *mŏt*, can be applied to any artistic happening. It is difficult to pinpoint in scholarly terms what *mŏt* is or should be, but easier to use the colloquial approach. *Mŏt* can be applied to the performing arts or the plastic arts, but it also refers to "artistic behavior" in man. Modern restaurant hostesses might say to themselves "He is a man of *mŏt*!", when they see someone who dresses expensively with an eye-catching coiffure, drives a nice car and throws generous tips. However, the traditional *kisaeng* girl would require more subtle qualities such as a good education as judged by her ability to compose poetry, write calligraphy and create paintings or relate an intelligent story. It means that Korean people sense art in every common happening of life instead of feeling it solely for things identified as "art." A happening with *mŏt* must be, first of all humorous, also creative and splendid; it must be unpretentious and contain such artistic characteristics as spontaneity, vitality, generosity, openness, honesty, refinement, breadth and simplicity. To explain the delicate shading of this aesthetic folk vocabulary, a number of native Korean expressions need to be explained.

Siwŏn hada (시원하다)

In the midst of a boiling hot summer day, all of a sudden if a cool breeze happens to pass by, Koreans will say *siwŏn hada*. At a critical moment of political corruption, if a military revolution takes place so that the corrupt social elements are cleared away, Koreans also exclaim *siwŏn hada*. Early in the morning, men with a big head from a hangover usually take exceedingly hot bean sprout soup to kill the wine's poisons. Even as their throat is burning with hot soup, the Korean drunkards shout *siwŏn hada*. If a painting conveys such a sudden clearing feeling as described above, Korean folk praise it with the same *siwŏn hada*. It means a work of art possesses such qualities as fluency, openness, smooth flow, unity, vital swing, simplicity and honesty.

The opposite sense in art would be *taptap hada*, an epithet applied in daily life on such occasions as when a drain pipe is plugged, a motor doesn't start, a man wastes time not knowing how to operate a projector, or a wife doesn't understand her husband's big ambitions!

Ŏullinda (어울린다)

If a bride and groom are well-matched, necktie and suit complementary, house and surroundings arranged, Koreans praise with the words *ŏullinda*, implying the harmonized and complimentary, or a pleasing contrast. This phrase they also apply to folk painting, if it has the same characteristics.

The opposite expression, *ttabun hada* or *ŏsaek hada* are used when a man with short greasy hair stands out in the midst of a crowd of long-haired hippies, a man at a dance party doesn't know how to dance, or a guest at a *kisaeng* house can't give an elegant wine toast. These derogatory terms may be attached to a painting which lacks visual harmony with its environment.

Siwŏn hada. Korean literati painting. Jumping carp. Yi dynasty. Collection of the Emille Museum.

Ōullinda. Korean literati painting. Rock bamboo, orchid and calligraphy harmonized. Collection of the Emille Museum.

Agijagi. Korean folk painting. Rabits under moonlight. Yi dynasty. Collection of the Emille Museum.

T'ŏlt'ŏl hada. Korean Zen painting. Hansan and Sŭpdŭk. Yi dynasty. Collection of the Emille Museum.

T'ŏlt'ŏl hada (털털하다)

In ordinary speech this term indicates true respect for a man with a good education, high social position and moderate wealth who behaves humbly by wearing inexpensive clothes, drinks ordinary cloudy wine with country people and talks plainly and frankly without pretense. When such a person drinks cloudy (unrefined) wine in a straw hut with a humble snack of octopus legs, Korean folk say he is exhibiting *t'ŏl t'ŏl hada* taste. When the straw roof is arranged naturally without trimming straws to form a clean edge, Koreans use a variant of this term (*t'ŏpt'ŏp hada*), which connotes the beauty of the unpretentious, honest exposure and humbleness. Artificiality or make-up is one of the most despised qualities in Korean art so folk paintings seek to avoid any impression of false pretense. A high official reading a long, boring, prepared speech, a woman wearing shining jewelry all over her body and thick make-up on her brows and lips, a house crowned by a roof with mass-produced slates — all such things are considered as revealing a low-level artistic taste. In painting, too, this same quality is detested by ordinary Koreans; naturalness is the goal.

Agijagi (아기자기)

Koreans would say a man appears to enjoy an *agijagi* life if he has a good wife, long surviving parents, many prosperous children, a household in good health and peace, perhaps a cute puppy, a kitten, a dozen chickens, and a cozy flower garden with strange stones for good measure, even one excellent antique work of art. Although not a millionaire, he seems to have about everything necessary for an enjoyable life. Contrary to this, they will classify his life as *ŏngsŏng hada*, if he is seen to have a brutish wife, frequent quarrels, no living parents and no children even if he lives in a huge house without financial cares.

These terms, too, are borrowed for the visual arts. *Agijagi* connotes a pleasing variety in a composition or design, yet compactness and order. For example, if the ten symbols of long life are condensed well into one scene, the colloquial aesthetic term of praise is *agijagi*. Contrariwise, if the composition is discordant, overcrowded, or not well-organized and simplified, it becomes *ŏngsŏng hada*.

Tchaptchal hada (짭짤하다)

Next to the optical, the tongue is used as a guide to create appreciative terms for art. A popular Korean saying runs "A small pepper is hot, and so is a short skinny man." A parallel English expression describing a person's character in terms of flavor goes "She is very sweet." Let us sample Korean aesthetic epithets by looking at the one word "salty." In English or in Japanese there is only one word "salty," but Korean sensitivity has developed a half dozen terms for different qualities of saltiness; *tchada, tchaptchal hada, tchiptchil hada, tchŏptchŏl hada, sigŭm t'ŏlt'ŏl hada*: these are *not* degrees of saltiness but describe variations in quality. Of these terms *tchaptchal hada* is the one most often used to describe a work of art, particularly by antique dealers. When beef is barbequed into beef

pulgogi, seasoning is very essential to bring out the flavor. Salt, garlic, sugar and soy sauce are used to augment the original taste, and a great deal of attention must be paid to the method or technique whereby the condiments contribute to the end result. If it is done right, the approbation *tchaptchal hada* results. An antique dealer who discovers an old painting which is still in good condition, clean and yet well-seasoned by the passing of time so that it has an added pungency and will bring more money than initially, would exclaim *tchaptchal hada*, "It is salted."

Kusu hada (구수하다)

Sweetness as well as saltiness is applied to art appreciation. When rice cakes are covered with sesame seeds the taste to a Korean becomes *kusu hada* and when dressed with baked red beans this taste is *kusu hada*. Likewise, if a good hearted, rather fat country winehouse lady generously treats her guests with ample snacks and drinks, her personality is praised as *kusu hada*. It takes humbleness, ampleness, roundness and good taste to be called by this term. Folk painting is also described as *kusu hada* if it uses a slow, wide line, without sharp corners, instead of the hard, fast line of classical painting.

Pudŭ rŏpta (부드럽다)

Finally let us examine some peculiar Korean expressions in the tactile realm which occur when we feel the texture of fabrics or paper. *Pudŭ rŏpta* is frequently heard from Koreans who love to use it for the most pleasant tactile sensation. This includes or implies such qualities as soft, mild, smooth, harmless, kind, gentle or peaceful and friendly. It can be applied not only to materials but to personal character, drama, music, dance, sculpture or painting.

This sensibility of *pudŭ rŏpta* is of particular significance in

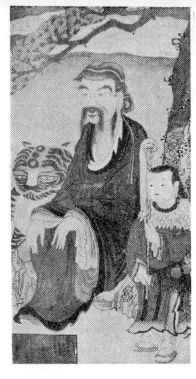

Pudŭ rōpta. Korean shaman painting, entitled Mountain spirit. Yi dynasty. Collection of Chikchi-sa Temple, North Kyŏngsang Province.

Korean folk painting, for friendliness is one of the first qualities we rejoice in when we see a painting. In general even supposedly furious images for evil-repelling, such as tigers, lions and dragons all are given a smiling face or at least a harmlessly soft face when they are adopted by Korean folk painting. Such gentleness is also appreciated in another Korean term *sun hada*.

If we carefully analyze Korean folk painting according to the materials available, it is soon evident that Korean artists were never successful in depicting war or creating glorified pictorial accounts of it. They could not make war look interesting or beautiful as some nations' artists did. Korean masterpieces all lie in the realm of the peaceful. Of the five human organs of sense, the optical, taste and tactile feeling have created these gut-level aesthetics for Korean folk painting, and as such can be expressed best by distinctive Korean terms. They cannot be translated exactly into any other language without an individual having the physical experiences which Korean people know through long association with their own art. By putting these various sensibilities together they experience a feeling of beauty,

which is generally known as *mŏt.*

Materials, Tools, and Techniques

The Concept of Kŭrim

We have just discussed briefly some of the typical aesthetic terms commonly used by Korean people in everyday life. In spite of the fact that they are measuring standards for Korean art, these terms are not used by modern art critics. Instead, they still employ old literati expressions or else terms which are literal translations from European theories of aesthetics. Strictly speaking, there is no Korean term corresponding to the Western term "painting," interpreting it in the sense of "paint" plus "ing." The Korean term *kŭrim* is much broader than the Western word "painting," and is applied to any representation of graphic work, regardless of material, tool, or technique needed to produce it. One other thing needs mentioning; *kŭrim pon* means base paintings, those used as the guiding base for embroidery or woodblock carving. *Kŭrim pon* is also employed in the beginning of Buddhist ritual painting, and for this reason some scholars decline to accept Buddhist ritual painting under the fine arts. But to people's amazement *kŭrim pon* was also utilized by literati painters and court artists, proving that most paintings were mass produced. No matter how many times a composition was copied from one *kŭrim pon* or who copied it, still there was one artist who created the initial base painting or *kŭrim pon.*

Since the Korean term *kŭrim* implies a wider range of graphic art than just painting, we must acknowledge that there are other art forms besides folk painting which should be explored along with its study. In other words, there exist in Korea closely associated art forms such as embroidery, woodblock prints, pyrography, leather painting and pattern design all of which follow the same guides as folk paintings do

in their symbolism, place of use, and time or occasion of use. Since each of these arts would require a tremendous amount of work to cover in detail, we will just briefly mention their nature and relationship to folk painting.

Embroidery and Folk Painting

Practically all themes employed for screen paintings in Korea have been reproduced in embroidery. However, this does not mean that embroidery is mere copy work. Rather a unique form of *kūrim pon* has been independently developed for embroidery work itself. In general, we get an impression that the well-known masterpieces of Chinese embroidery in most cases are the precise reproduction of classic paintings by application of such fine needle work that it becomes hard to distinguish embroidery from painting. In Korean embroidery too we often find exact copies of paintings done by well-known painters. Nevertheless, more significance may be seen in the unique art of base painting, whereby folk painting and embroidery are linked. Therefore, the study of Korean embroidery must explore two aspects, namely the technique of thread work and the art of base painting. As far as the thread work is concerned, its unique characteristic is the use of thick-twined thread instead of fine single thread. This results in a quality of naturalness without masquerade, just as Korean carpenters use undistinguished rafters to define their houses or painters choose heavy native mulberry tree bark paper to express ruggedness. One other distinct feature of Korean embroidery is its simple abstract nature which sometimes supercedes modern abstract art. This quality is no doubt accomplished by base painting in which even court painters participated. Just as there is high and low folk painting, in embroidery too there are high and low works according to the level of artist and users.

Generally, embroidery is known as woman's art in which every woman from queen to peasant girl participated, some as

professionals and others as amateurs. In a few cases men also took part in Korean embroidery. It is widely known that some of the finest needle work was done by Buddhist monks and this is usually treated as Buddhist embroidery. Korean embroidery work may be divided into two groups, small-scale crafts and large-scale screen art. Craft art includes such daily items as pillow cases, spoon bags, hats, socks, dresses, handbags, mattresses, blankets and various covers. Symbolic patterns, such as longevity, happiness, and evil-repelling, are incorporated. As in painting the dominant theme for screen work is flowers and birds. Other popular themes found are one hundred babies, character design, tiger hunting, ten symbols of long life, the Diamond Mountains, rock designs, and book scenes.

Woodblock Prints and Folk Painting

Korea is known as one of the earliest printers in human history, if not the first one. This status has led modern academic research to concentrate basically on book-printing art, forgetting almost completely about the charm of popular woodblock picture prints. Because Korean woodblock prints are primarily single ink color they have not been appreciated by Western eyes as much as the multi-colored Japanese prints. In recent years several woodblock prints of extreme aesthetic quality have been discovered. This may be a fraction of the Yi dynasty production, but it hints the potential of this forgotten art. Contrary to the usual understanding of Korean woodblock prints, this includes such small daily items as stationery and book cover prints, huge screens of the one hundred longevity symbols, one hundred good luck symbols, the landscape map of P'yŏngyang, Diamond Mountains, the book pile scenes, character designs and various masterpieces of calligraphic works. In addition to this, several masterpieces of Buddhist prints have been collected. As in the case of ritual painting Buddhist picture prints help by furnishing recorded dates for works which are not discovered in other prints. According to

Sung An Book Museum the earliest Buddhist picture print ever discovered in Korea dates from 960 A.D. As the art of embroidery was seen through two aspects, woodblock prints too may best be evaluated by dividing them into two groups, namely small-scale crafts and large-scale picture prints. The first includes base prints for embroidery work, stationery papers, ornamental stamps, prints for book covers, fabrics, maps, geomancy maps, amulets, charms, dooť prints, and book illustrations. Although they are small in scale all people participating in this humble folk art treat them as a means of beautifying daily life.

On the other hand, large-scale prints, particularly in the form of screens, seem a major parallel to folk painting. Since wood products are difficult to keep, only a meager number of relics have been preserved from which to visualize this old Korean art of picture prints which has long ago disappeared from our reach. As Ryochi Kumata, one of the earlier Japanese collectors of Korean folk art, once said, "Judging from the eight-panel P'yŏngyang landscape map screen, Korea in the past probably had the largest-scale woodblock prints of any country."

Pyrography and Folk Painting

We must be aware of the fact that the Orientals too have had hard point graphic art beside their traditional hair brush painting. There is one other important folk *kŭrim* which has long been neglected. This particular technique is called *indu kŭrim* which literally means "scorched picture." Such work is done with a series of metal tools, similar to dentist's instruments. The craftsman lightly burns or at least scorches his paper, wood or bamboo so that the resultant design is dark brown upon the lighter beige of the original paper. Pyrography or *indu kŭrim* is the most typical representation of Oriental hard point graphic art. This amazing art of scorching

also can be divided into two groups, namely craftsmanship and major folk art. Since wood and bamboo are dominant materials in Korean folk art, pyrography was extensively applied to these materials, but paper was also important. Pyrographic crafts include such daily items as combs, fans, brush holders, arrow boxes, cups, pipes and tiny pictures to be pasted on doors. Just as Korean folk painting themes are used in embroidery and woodblock prints, they also occur in pyrography. While embroidery and woodblock carving depend on the base picture *kŭrim pon*, pyrography does not utilize such a guiding base but is an independent creative graphic art. Since Korean folk painting itself has long been neglected, pyrographic creations are even more scarce. A few survived by a miracle include an eight-panel screen of flowers and birds, which is unbelievably skillful. Also preserved is one panel of an animistic type pine tree, and a few pieces of landscape. These hint at the expertise and the scale of this art which once flourished in Korean villages.

Leather Painting

When Orientals say "brush" they associate this with a brush pointed at the head while Westerners normally think of brush with a flat edge. If a flat brush is fabricated from a piece of leather instead of hairs, this is the exact instrument old Korean folk used to produce leather painting. Such a special tool creates lines of different widths, and when moved rapidly it develops an even more fascinating effect. Native country folks were very fond of this unique style of painting which usually was produced at very cheap prices at the market place. Since no masterpiece is known within this painting category, we may recognize this as typical of folk painting produced by ordinary craftsmen and bought by poor peasants. The old records state that formerly they used shredded willow wood instead of leather for brush hairs. The favorite theme for this

technique appears to have been character design, developed by modification of various Chinese characters, linking up the shapes by fat brush lines. Until about thirty years ago we could find an excited crowd bent in L-shape watching as some fellow proudly demonstrated this art, criticized or praised by ordinary people. This may be an excellent example of the folk art of participation.

Threadgraphy and Folk Painting

Threadgraphy is a term created to translate the Korean word *silppobi kŭrim* which means "a picture created by pulling inked thread." First we soak a handful of thread with ink and arrange it on clean paper in the desired shape, then we place another sheet of paper on top of it. After this we put large books on top of them for weight. Now from one corner we pull the thread out slowly and carefully, so that a fanciful design in abstract form is created. This technique was particularly effective for the decoration of small daily objects such as book covers and stationery, but sometimes we find significant works of art in the folding screen format leaving us a challenging area to explore.

Often we run into unbelievably abstract forms of folk painting. Threadgraphy provides evidence that explains how abstraction occurred from various natural phenomena.

Color and Size

As a rule of thumb the paintings done in thick color generally are ranked as folk painting. As mentioned before, it was Yi dynasty literati painters who actually established such criteria. It is true that religious paintings and court paintings all employ exceedingly heavy mineral color which is applied with glue and water. Domestic folk painting, on the other

hand, employs all sorts of colors, including plain black ink, light water color, grape juice, thick mineral pigment and often golden color. Of such binders, thick glue color painting is most esteemed regardless of the bitter criticism of the literati painters. Besides, mineral pigments were so expensive that some of the rarer colors were as valuable as gold. This means that mineral pigments, mostly imported from China, were treated as a treasure; and even today antique dealers ask heavy prices for good gold paintings done in so-called *Tang ch'ae* or heavy mineral color. This fact offsets the usual concept of Korean paintings as done in light color and small size.

Some art historians have insisted that the size of Korean painting is generally small because of the poverty of the country. Since the past art histories were based on the works in the National Museum and other collections of literati paintings probably, it was inevitable that such an impression arise. An entirely opposite conclusion may be drawn if someone writes a history of Korean art solely based on religious paintings and court paintings.

Kwaebul or the hanging Buddha portrait, extends up to 35 feet by 45 feet and it takes a hundred men days of labor to install it. It is estimated that there are still about such a hundred paintings preserved in various temples in Korea.

Painting Base — *Pat'ang*

In Buddhist pagoda architecture Chinese people preferred clay brick, Japanese specialized in wood, and Koreans favored granite. As a result the Chinese brick pagoda, the Korean stone pagoda, and the Japanese wooden pagoda show the individuality of each country within the common field of Buddhist architecture. Likewise, in painting Chinese people preferred fine Chinese paper or Chinese silk, Japanese developed soft paper and clean silk to suit themselves while Korean people throughout history insisted on their own

mulberry paper. Consequently one way of distinguishing the origin of Oriental painting is by careful examination of the material. The Korean term *pat'ang* means base or foundation or "field to receive the seed." Just as they preferred pine for a house and hemp for a dress, so the thick, tough paper made locally from the bark of the mulberry tree is considered the best, for in painting too Koreans strive to express the feeling of naturalness, unpretended ruggedness. When elaborate details are to be included in a painting, there is a special treatment for the paper called *tadūmi*. This refers to rolling wet mulberry papers around a wooden roller and beating them with a wooden bat all night. Such technical know-how is still possessed by a few Buddhist monk-painters today.

Analytic Classification of Korean Folk Painting

KIM HO-YŎN

Folk painting refers to painting done by artists who constitute the undercurrent of a society. In any society, therefore, folk painting is outside the mainstream of art. In other words, folk paintings are usually considered artistically inferior works which do not belong to the main current of art. As a result, numerically and stylistically folk paintings are usually not comparable to mainstream paintings.

But in Korea, folk paintings are as good as mainstream paintings not only in subject matter but also in style, and it is therefore very hard to draw the border-line. In any country, it is not easy to define the concept and scope of folk paintings. In the recorded history of arts in Korea, artists are chronologically grouped, along with their works, and many historical paintings remain anonymous today. As a matter of fact, anonymous works far outnumber signed works in various art collections. So, a narrow view of folk painting would exclude many anonymous works of fine artistic value from the art history of Korea. This is one of the weak points of Korean art history as recorded today.

In Yi dynasty folk paintings were done by folk painters, who constituted the lowest class of society, to meet the demand of the common people. Many "vulgar" imitations were drawn, but the original paintings were of such fine artistic value that they must have constituted the main current of art. So, to

understand folk paintings of Korea we must examine how these vulgar imitations appeared. It was after the 18th century that these vulgar imitations became popular among common folk, and this coincided with the rising popularity of folk literature and folk music.

The term, "folk painting," was first used in Korean art society around 1960 when it was introduced from Japan. The meaning of this term, as used in Western countries, does not help understand the works and events of the art history of Korea. On the contrary, the vagueness of the concept has led, more often than not, to a distorted interpretation of the works and events of the art history of Korea. Such a distortion is not limited to folk paintings alone; it is also extended to folkcraft and folklore.

So, establishing a clear definition of the concept of folk painting involves rewriting the art history of Korea, and this requires balancing the concepts of folkcraft and folklore with that of folk painting. This paper attempts an analytical classification of Korean folk paintings of the Yi dynasty period.

Yi dynasty folk paintings extant today can be classified into many categories by subject matter. For instance, paintings of flowers and birds are portrayed with flowers of various pairs of birds and the paintings of a tiger and seasons and magpies show a tiger gazing at something and magpies on a pine tree whispering to the tiger.

In this paper, such folk paintings are classified into 36 categories or types by subject matter, and each category or subject is considered to be directly related to the way of living of the people. For example, paintings of flowers and birds are for the decoration of the bedroom of a newly-wed couple. In this category of paintings, a pair of birds invariably play on beautifully colored flowers. In other words, the composition is the same in all paintings of this type, though the level of artistic value varies according to the skill of the painter and the social status of the people who commissioned the painting.

The fact the Yi dynasty folk paintings were closely related to

popular demand tells that these paintings were not for the sake of art but for the sake of practical use. Because such paintings were for practical use, the painters did not feel the need to show their individuality and creativity in most paintings, nor the need to autograph their works.

Although composition was almost the same in a particular style of paintings, painting techniques changed as time passed. Of course, there were many imitations, with the development of imitation techniques.

A discussion of each of the 36 categories or types of Yi dynasty folk paintings follows.

1. *Paintings of Flowers and Birds*

Among the Yi dynasty folk paintings remaining today, paintings of flowers and a pair of birds constitutes the largest category. The paintings vary slightly from one another in composition. They are to be seen on an old eight-panel screens. This screen with pictures of flowers and birds in a dreamy composition and beautiful colors was for the decoration of the bedroom of a newly-wed couple. The embroidered screen of today for room decoration is usually a copy of this eight-panel screen with pictures of flowers and a pair of birds.

2. *Paintings of Flowers and Insects*

This category includes paintings of flowers and insects such as bees and butterflies. While the flowers in the previous category of flowerbird drawing are of woody plants, those of the present category are of herbaceous plants. The paintings in this category are generally realistic, and the oldest remaining one is believed to be a work of the 16th century, when Madam Sin Saimdang, the mother of the great Confucian scholar Yi Yul-gok, first drew a picture of summer flowers and insects. Most paintings remaining today are more or less an imitation

of her work. This drawing is also seen today on an old eight-panel screen which was used to decorate the room of the family head's wife.

3. *Paintings of Peony*

This painting was also for use on an eight-panel screen, though there is no variation of composition in the paintings on the eight-panels. The size of this painting is generally large, compared with the foregoing two categories. The screen with this painting was used to decorate a wedding ceremony which took place in the front yard of the groom's or bride's house. Historical records say that poor people borrowed this screen when they got married, and this means that the screen was expensive for poor people in the Yi dynasty period.

4. *Paintings of Lotus Flowers*

Another painting for the eight-panel screen, this drawing of lotus flowers is either included in the previously-mentioned category of flowers and birds as a picture on a particular panel of the screen or spread over all the eight panels of the screen, creating a unified whole. In the Yi dynasty period, middle class and above families had a pond with lotus in their courtyard. In general, Koreans like lotus paintings and many Korean artists still like to draw such paintings. The screen with lotus flowers was used for room decoration in summer.

5. *Paintings of Cupboards*

This category includes the drawing of a cupboard with some tableware and books, and it was also for use on the folding screen. This painting has no blank space in composition and gives a three-dimensional realistic feeling with perspective and shading techniques. Such techniques of composition make this painting exceptional as an Oriental painting, because Oriental

painting does not use these techniques. Some earlier paintings of this category remaining today include an alarm clock, in addition to books and a cupboard, which clock was first introduced to Korea by way of China in 1631, 70 years after Italian Missionary Mateo Ricci first brought the clock to China. But the perspective and shading techniques in painting are believed to have been developed in Korea far earlier than 1631, and this is now being intensively studied by many scholars. No "vulgar" imitation of this painting is found today.

6. *Paintings of Bookcases*

Having a bookcase, a table with piles of books and other furnishings, this bookcase drawing depicts the living room of a Yi dynasty Confucian scholar. This painting was also for use on the eight-panel screen, and the composition is slightly different from panel to panel. In the 19th century, this category of painting was drawn in combination with other categories. For instance, lotus flowers, fish and birds are seen above the bookcase in the paintings of this category done in the 19th century. Munayoshi Yanagi (1889-1961), a Japanese scholar of Korean art, highly praised this category of paintings, calling it a wonder of Yi dynasty art.

7. *Paintings of the Eternal Symbols*

This painting is of 10 things symbolizing long life — the sun, the moon, clouds, water, rocks, pine trees, turtles, cranes and tortoises, though some paintings remaining today are without one or two of the above 10. The composition of this painting for a long life is usually spread over the eight-panel screen. Of the paintings on the screens used by noblemen, many were drawn on silk cloth, not on paper, with water colors and oil colors, though with water colors alone in most cases. Because the silk cloth was not treated as the canvas for Western painting is done today, the life of a painting on silk cloth was

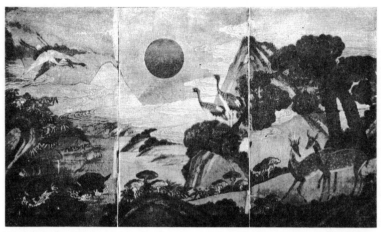

Ten symbols of longevity (detail of a screen), Academy of Painting, 18th Century.

relatively short.

8. *Paintings of Sun and Moon*

Spread over the eight-panel screen for use by a king behind his office chair, this painting has several mountain peaks, the sun, the moon, the spray of waves and pine trees. Though simple in composition, the drawing represents the authority of a king with its beautiful and noble coloring. Because this painting was exclusively used on palace folding screens, commoners were not allowed to have one, though some extremely varied forms of this painting were found in the private possession of some common people.

9. *Paintings of the 12 Directional Signs*

This drawing is of the 12 directional signs — mouse, ox, tiger, rabbit, dragon, snake, horse, goat, monkey, chicken, dog and hog. These directional animals are said to have originated in Taoism of China as guardian deities of the 12 directions, and these animals, actually their pictures, were

long used in Buddhist ritual as guardians of the place where such rituals were held. The paintings of these animals were not for use on folding screens, and they usually hung in the pertinent direction.

10. *Paintings of Four Deities*

The four deities in this category of paintings are the blue dragon, the white tiger, the red bird and the black tortoise, all believed guardian deities in Taoism. The earliest paintings of these deities in Korea were found in the murals of Koguryŏ tombs of the 6th and 7th centuries. The four gates of Kyongbok Palace in Seoul also have the paintings of these four animals, one painting on each gate. In the Yi dynasty period and before, the paintings of these four deities were used not only in royal tombs and palace buildings but also in public buildings as their guardians. Because these animals are the guardians of the outer area of a building, they have a similarity to the use of the 12 directional animals and the four Buddhist heavenly kings. But in paintings extant today, the 12 directional deities and the four heavenly kings invariably hold some weapon in their hands, while the four deities have no weapon whatsoever, indicating that they can expel the evil without the help of a weapon. Some scholars believe that the paintings of the four deities must have developed from the paintings on totem poles in ancient Korea.

11. *Paintings of Magpies and Tiger*

This category of paintings is not realistic but imaginary, presenting magpies and a tiger as messengers of the mountain and village deities. In the Yi dynasty period and before, the scroll of this painting was hung in a house on the lunar New Year's Day, with the belief that the magpies and tiger would protect the family from evil in the coming year. The magpies are invariably above the tiger in all paintings of this category

remaining today, because the magpies as messengers of the village deity must have something to tell to the tiger as a messenger of the mountain deity. In Korean folklore, magpies are said to be the carrier of good tidings. While earlier paintings have a striped tiger, the paintings of the late 19th century have a checked tiger.

12. *Paintings of Tigers*

The tiger paintings remaining today have no background story, and they appear to be relatively recent works compared with other categories of paintings. In addition, the tiger in these paintings is more realistically and objectively presented than the tiger in other categories of paintings, and this can be said to be a result of some big change in the people's way of viewing things, because in these tiger paintings the tiger, long considered a messenger of the mountain deity, is depicted realistically and objectively. And this change in the way of thinking is considered to have been caused by Silhak thought. Silhak School, which began to have influence on Korean society in the 17th century, helped the people see things objectively and realistically. This must have caused some folk artists to draw a tiger objectively and realistically, without any background story. If so, there must be no realistic painting of tigers done before the 17th century, but among the realistic tiger paintings remaining today are the ones done in the 16th century, and what they mean in the history of folk painting is not known today. Moreover, although tiger paintings of the 17th century and thereafter are objectively drawn, very few realistic paintings remain now and most are similar in technique to other categories of paintings.

13. *Paintings of Tiger Skins*

Up to half a century ago, there had been a practice of putting a blanket with the picture of tigers on the top of the bride's

sedan, and this tiger blanket was considered a replacement of tiger skin. This means that in earlier days the real tiger skin was used as the top cover of the bride's sedan, and historical records talk about tiger hunting. Although the tiger was respected as a messenger of the mountain god, it was also a hunting target, and the dead tiger's skin was used as protection against evil. This complex idea forms the consciousness structure of the Korean people, and with this complex of opposing ideas the Korean people developed the power to achieve a harmony between the two ideas. The tiger skin painting is usually seen on old eight-panel screens today, as other folk paintings, being spread over the whole eight panels, and the painting is so realistic that it gives a feeling of being overwhelmed.

14. *Hunting Paintings*

This is a painting of armed people hunting in rugged mountains. According to Chinese records, it was Chen Chuchung of Sung China who first developed the style of hunting pictures by drawing a picture of hunting by Mongolians who invaded China crossing the Yinshan Mountains. So, it can be said that underlying the hunting painting of China was the Chinese people's sense of resistance to the Mongolian invaders. Likewise, the hunting painting by King Kongmin (1352-74) of Koryŏ can be considered an expression of the Korean people's hatred for the Mongolians who then ruled the Korean peninsula. The king's painting, worn to pieces, is now kept at the National Central Museum in Seoul, and many hunting drawings of the 518-year Yi dynasty period followed King Kongmin's painting in technique and composition. The hunting painting is also seen on old eight-panel screens today, being spread over the whole eight panels, though there are some screens which have a painting slightly different in composition from panel to panel. This screen is believed to be used for the decoration of military conference rooms and the

residences of military officers.

15. *Dragon Paintings*

In the Orient, the dragon is an imaginary animal whose shape was first completed in China during the Han dynasty period. So the dragons appearing in the pictures of the Yin and Chou periods are incomplete ones. It was after the Han period in China that the dragon was first introduced to the Korean people, and the dragon, believed to be a representative of the heavenly god, has since had influence on everyday living of the Korean people. For example, the Chinese character meaning dragon is still found in many place names and men's names. In prayer meetings for rainfall the picture of a dragon appearing from clouds was worshiped. The dragon paintings of the late Yi dynasty period remaining today are invariably similar in form to the wooden dragon found on the eaves of palace and temple buildings. There are two kinds of dragon paintings, blue dragon and yellow dragon, and the yellow one is said to represent the authority of a king. The dragon painting is not for screens but for scrolls hanging in the living room of a family head.

16. *Falcon Paintings*

The falcon painting was put on the doorway of a house as an amulet against misfortunes. Because man has to face some kind of bad luck during his life, the people of Yi dynasty believed that the falcon talisman would protect a man from such misfortune. They used the drawing of a three-headed falcon, and because the demand for the falcon amulet was high, the drawing was printed for mass production. Nine out of the 10 falcon drawings remaining today are prints, and brush drawings are very rare.

17. Fish Paintings

Fish drawing was for use on screens, and sea fish were drawn with river fish in the same painting. Only a few very realistic fish paintings, believed to be works of the 17th century, remain today, and the paintings of the 18th century and thereafter cannot be classified into this category because they include subject matters of other categories, in addition to fish. This was not because the people of the time did not like fish paintings but because they found less use for fish paintings than for other paintings. In Korean folk paintings, a new type of painting developed according to demand of the people in their life, and the type whose use was low did not last long. For instance, the fish painting and the lotus flower painting had low use to the people.

18. Paintings of Eight Scenes

Of the landscape paintings extant today, the paintings of eight scenes are the largest category. The eight-scene painting was for use on eight-panel screens, and the scenes were of the eight scenic places of a specific area. According to historical records, the first eight-scene painting in Korea was done during the rule of Koryŏ King Myŏngjong (1171-97). The eight-scene paintings extant today are of such scenic areas as the east coast of the country, Pyŏngyang, Seoul, the suburbs of Seoul, the west coast, Cheju Island, Tanyang and the south coast. While the earlier paintings are realistic in the expression of scenes, the later paintings are so similar to each other in technique, form and composition that the scenes cannot be identified unless the painting has a place name. So the painting with no place name is easily taken as a landscape painting, because the scene cannot be identified.

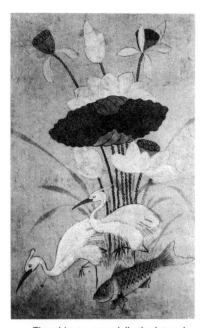

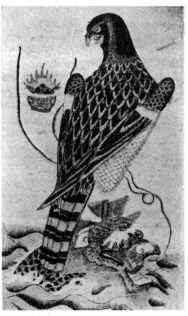

The objects, especially the lotus, in this picture are most common among eight-panel screen of Yi dynasty

The falcon, which is regarded as dispelling evil spirits, is painted in a realistic style on an wood-engraved print.

19. *Landscape Paintings*

Landscape painting in Korea differs from eight-scene drawing and scenary drawing in that it is not a depiction of the landscape of a specific area but a presentation of the landscape of an imaginary utopia. Such a utopia and other imaginary things are the most popular subject matter of past Oriental painting, and painters were fond of drawing what they dreamed about, though Korean painters were less fond of such paintings than their Chinese counterparts.

20. *Paintings of Diamond Mountain*

The Diamond Mountain is famous for its beautiful scenary, and every Korean wants to visit it. Because it is situated in an

area of 160 square kilometers, it is very difficult to present the mountain in a single piece. But Chŏng Sŏn, penname Kyŏmjae (1676-1759), condensed it in a painting for an eight-panel screen. He also drew the mountain on a fan. Thus his techniques were followed by many painters and many imitations of his works appeared. Although the Diamond Mountain drawing was usually for eight-panel screens, during the late Yi dynasty period the mountain was drawn for a single panel of a screen.

21. *Scenary Drawing*

Scenary drawing is similar to the eight-scene drawing in that it depicts the actual landscape of a specific place. But it was for a scroll for hanging in a room or for an art collection, while the eight-scene drawing was for an eight-panel screen. This drawing is also different from the eight-scene drawing in that it is drawn in perspective. This perspective technique is unusual in Oriental painting, though it helps understand the situation of the landscape expressed in the drawing. When this technique was first introduced to Korean painting is not known. The scenary drawings using this technique extant today cover the whole spectrum of the Yi dynasty period.

22. *Map Drawing*

The map is not a painting, but there are maps which can be considered as folk painting. The map drawings remaining today are a mixture of the map and location scenary drawing. While modern maps correctly indicate places and the distances between them, the many map paintings extant today present typical scenes of places and do not indicate the location of places and the distances between them.

23. *Documentary Paintings*

Of the Yi dynasty paintings extant today, there are many documentary paintings related to historical events. These documentary paintings are classified into six groups: paintings of royal ceremony spread over an eight-panel screen which includes the description of the ceremony and the whole view of the ceremony and the palace grounds where the ceremony took place; the painting of a king's outing for a scroll which is rather a prepared schedule of the procession of the king's party than an actual presentation of the procession; the painting of a meeting of fellow workers or friends with description of the meeting; the painting of the 60th birthday party and other parties with the description of the party; the painting of an envoy visiting China or Japan; and the painting of battle. There are only a few battle paintings remaining today, such as the paintings depicting the Korean fleet engaging the Japanese during the Japanese invasion of the late 16th century, the Tongnae magistrate being killed in action in the same war and the fall of Pusan into Japanese hands also during the same war. These documentary paintings were drawn by government painters and therefore they are not considered folk paintings. Especially, the paintings of royal ceremony, king's outing and an envoy visiting a foreign country had nothing to do with the daily life of the people.

24. *Farming Paintings*

This category of drawings is of farming village life, depicting tilling, sowing, weaving and spinning. Usually, an eight-panel screen has eight paintings of different farm scenes peculiar to Korea in the Yi dynasty period. According to historical records, the farm drawing was first made by order of King Sejong (who reigned 1419-50), depicting purely Korean farm scenes of the time. China also has farm drawings but different in subject matter and composition from Korean drawings.

25. *Paintings of the Ideal Life*

This drawing is of the ideal life a Yi dynasty upper class man dreamed of, depicting his first birthday party, his education, his promotion in the government and his 60th birthday party. Along with the farming drawing, this is one of two mainstreams of Yi dynasty folk paintings. Because it presents the family life of the upper class people and the public life of government officials, this painting is considered a valuable reference to the study of Yi dynasty customs.

26. *Paintings of Games*

This painting depicts folk games of Yi dynasty such as kite flying, chicken fighting, hide-and-seek, swimming, dragonfly catching and shuttlecock play. Paintings of this category remaining today are believed to be works of the late 19th century, and the children seen in these drawings are similar in appearance to those in Chinese play paintings, indicating that the drawing of games was under the influence of the Chinese play drawing.

27. *Paintings of Fortune-telling*

This category of drawings is used for fortune-telling, some as illustrations of a fortune-telling book and others as illustrations of fortunes by fortune-tellers. The color is thick and the expression is direct and sensual, typical characteristics of folk paintings of the Yi dynasty period.

28. *Portrait Painting*

In Korea, the portrait has a long history, and portraits are different from so-called figure painting in technique. Especially, the Yi dynasty portrait was so drawn as to express the character. This portrait technique was developed by

government painters. In every middle class and above family of Yi dynasty was the family shrine where the portraits of ancestors were put in a frame, and this family shrine helped develop portrait techniques in the Yi dynasty period. Although most portraits of Yi dynasty extant today are works of government painters who followed the portrait techniques of the Koryŏ period, there are anonymous portraits attributable to folk painters.

29. *Paintings of a Story*

While the documentary painting is related to historical events, the story drawing is a visual expression or an illustration of a story. Korean story drawings are largely classified into three groups — novel illustration, fairy story illustration and heroic story illustration. The novel paintings extant today are related to such famous novels as the Three Warring States, the Nine-Cloud Dream and the Life of Ch'unhyang. Up to half a century ago, village folk used to get together in a big room of a house on winter nights to hear one of them reading a novel, while looking at paintings illustrating the main points of the story on an eight-panel screen near one wall of the room.

30. *Paintings of Shamanist Deities*

Shamanism had long been the folk religion of Korea, and drawings of shamanist deities were respected and worshiped by the people. In some paintings of shamanist deities, a historical person is drawn as the main deity, while in others an imaginary being is depicted as the main deity. Moreover, some shamans enshrined historical persons in their temple, while others enshrined an imaginary being in their temple. The drawing of shamanist deities is marked by thick coloring, like Buddhist paintings. Besides such shamanist paintings, there are paintings of a shamanist temple-like shrine encircled by

flowers remaining today, and these paintings were used by poor families, which could not afford to build a family shrine, as a replacement of the family shrine in ancestral service, placing the tablet before the painting. This painting had nothing to do with the shamanist painting.

31. *Paintings of the Mountain God*

The mountain god is a native religion of Korea and therefore it has nothing to do with Buddhism. It is believed that Korean Buddhists began to worship the mountain deity in the early Yi dynasty period. The paintings of the mountain god extant today are invariably of an old man sitting by a tiger.

32. *Paintings of Filial Piety and Brotherly Love*

This is a painting illustrating the eight cardinal principles of Confucian morality—filial piety, brotherly love, loyalty to the king, confidence in friends, social etiquette, justice, shame and frugality. It is assumed that this category of paintings developed between King Sejong and King Chungjong (1419-1514). While earlier drawing has pictures between strokes of the eight Chinese characters in square style meaning the eight Confucian moral principles, later drawing has the pictures outside the strokes. This drawing is also seen on an old eight-panel screens today.

33. *Calligraphic Drawing*

In this calligraphic drawing Chinese characters are drawn like a hierograph. Until half a century ago, such drawing was seen on the wall of a village inn and it was sold in market places. It is believed that this drawing is a variation of the drawing of filial piety and brotherly love.

34. *Paintings of Long Life and Happiness*

This painting expresses two Chinese characters meaning long life and happiness. On an eight-panel screen the two characters are drawn in various styles and beautiful colors. The characters differ in style from panel to panel, but they make a good balance when the screen is unfolded and viewed as a painting.

35. *Paintings of Dragon Fish*

This painting depicts a big fish jumping to the sky from the sea above which the sun is rising. The fish here means a dragon, though it is in fish form. This difference in form and meaning is often seen in folk paintings of Yi dynasty.

36. *Poker Drawing (Pyrograph)*

Poker drawing is done on paper or wood with a poker or a small iron, instead of a brush. Subject matter of the poker drawings remaining today are landscape, flowers and orchids, and some poker drawings are more delicate in composition than brush drawings. Poker drawings are chiefly for a fan, and this drawing is still made by poker painters today.

The composition and technique of folk paintings in 36 categories, as discussed above, cover the whole spectrum of Korean paintings of the Yi dynasty period. Some categories can be further divided, and this will add to the above categories. In addition, attempts are now being made to seek lost categories.

The study of Yi dynasty folk paintings is still in the infant stage, and to define the concept of folk painting in Korea, an effort must be made to study the original forms of the paintings now known as folk art. This is because in Yi dynasty folk paintings did not develop as an independent art form but developed as a variation of mainstream painting. As a result,

folk paintings were excluded from the main current of art history because they were drawn by folk artists to meet the demand of the lowest class of people in society.

Yi dynasty paintings were chiefly for folding screens for home decoration, and folk paintings were particularly used on such screens. This was because the painting was not for appreciation but for room decoration in Yi dynasty. And folding screens were most suitable to room decoration and to the preservation of paintings.

As a result, folk paintings had to become decorative, and because of this decorative characteristic, the painters tried to draw a picture enjoyable to everybody, instead of trying to assert his individuality, and this caused various styles of folk paintings to develop.

In every style of folk painting, a shift took place from realistic drawings to formalistic and picturized drawings. Then there appeared various variations of the style and imitations.

Yi dynasty folk paintings, be they variations or imitations, are characterized by beautiful colors. In fact, the beautiful and thick color is seen in all Yi dynasty folk paintings, regardless of style. Color evokes emotional feeling, and the colors of Yi dynasty folk paintings express the emotional feeling of the Korean people toward beauty. Such coloring is still found in modern Western oil paintings of Korean artists today.

Concluding this paper, I must say that an extensive study should be done to define the scope of folk painting in Korea.

Beauty and Characteristics
of Korean Prints

KIM CH'ŎL-SUN

Korean Prints Were Made to Be Developed

The art of the Korean print has a long tradition and distinct features. Nevertheless, the beauty and tradition of the Korean print is little known to the world. Compared with handicrafts and other genres of art, it is almost unknown. While the Japanese print claims an important place in the history of Oriental art, the value of the Korean print has not been estimated at all.

Various reasons account for the development of the Korean print. First of all, there is the love of books of Korean people. Until recently Koreans, even when they had to dispose of ricepaddies and household items because of financial difficulties, never sold books. Books were always highly prized.

Chinese historical records state that Koreans were avid readers from a long time ago. A chapter dealing with the Koguryŏ kingdom in Vol. 120 of T'ang-shu runs:

"... Koguryans (people of Koguryŏ), even poor people, were diligent in learning. They used to build a study called *kyŏngdang* in their garden facing the street where the young members of the family gathered and studied classics. ..."

In retrospect, Korea was able to offer a new culture to Japan because she loved learning and developed her own culture. How otherwise could she afford to provide Japan

with a wide area of heterogeneous culture for such a long period?

Koreans' love of books and learning means that they wrote and published many books. It is unlikely that the *Thousand Chinese Characters* (千字文) and other classics brought to Japan by Wangin (Wani) of Paekche were thoroughly Chinese in nature. The paper produced in Korea during the Koryŏ and Chosŏn dynasties was evaluated in China as of the highest quality, because the production of quality paper for printing books was encouraged and therefore the technique of paper production was highly developed in Korea.

The fact that Koreans invented the earliest metal type in the world indicates that they had a will to produce thousands of good books. It is amazing that techniques of printing were developed in a small country neighboring China for the purpose of printing quality books in profusion. This is a more significant fact than the fact that the Korean invention of the world's first metal type was earlier than that of Gutenberg in Germany. We cannot overlook the fact that Koreans developed new printing techniques to produce beautiful type and woodblock prints. It was natural that woodblock illustrations printed in the books were developed in Korea.

We must also cite the Korean outstanding esthetic sense, the instinctive response to beauty itself. In the relics from the Neolithic Period and Bronze Age, for instance, we find various designs, such as dots, rectilineal and curvilineal lines, and impressed rope patterns. We also discover ritual and daily utensils ornamented with circles, rectangles and leaf-shaped patterns which reflect that ancient Koreans wished to live surrounded with these beautiful designs.

As we examine such early designs and the designs from the Three Kingdoms, Koryŏ and Chosŏn periods, we come to realize that the extant rhombic floral patterns and patterns carved in cake molds and woodblocks are of ancient origin.

Such designs applied on books, wrapping clothes and papers can be found in our neighboring countries as well. But the

esthetic sense of Koreans is a little different. We can trace the same characteristics in the beautiful forms rendered in the plastic arts such as painting, sculpture, architecture and handicrafts as well as in such intangible arts as music, dance, drama, poetry and prose. Thus, it is quite natural that Korean woodblock printing had to develop under such circumstances.

There Exists a Rich Repository of Woodblocks and Woodblock Illustrations Dating from the Koryŏ Period

Anyone who has studied Korean woodblock prints to a certain degree can easily realize that the previous deduction is identical with the facts. It has been rumored that some woodblock prints dating from the Three Kingdoms and Unified Silla periods are still extant. Though no exact data on such prints exist, it is possible that they will be discovered as a result of future investigations.

However, there are many woodblocks and woodblock illustrations dating from the Koryŏ period. Among them are those of the first Tripitaka Koreana in 570 sets and 5,924 fascicles produced between 1011 and 1037. The woodblocks were destroyed by the Mongolian invaders in 1233, but 1,715 fascicles with illustrations are still preserved in Nanzen-ji temple in Kyoto.

Four of the woodblock illustrations were acquired by the Sŏngam Archives in Seoul in 1976 and were displayed to the public in the following year. Plate 1 is one of the four scenes illustrating the contents of the 10th scene of the 6th fascicle. It depicts the inscription at left — the clouds over the seashore, a grass-thatched cottage, and movements of a number of figures in the heavily-wooded mountains.

Between 1073 and 1090, 4,740 more fascicles of the Tripitaka were compiled, but they were again destroyed by fire. Some of the woodblocks remain in Songgwang-sa temple. A total of 81,137 woodblocks produced between 1236 and

Plate 1 Plate 2

1251 are preserved in Haein-sa temple. These woodblocks do not contain illustrations, but we cannot but admire the elaborate forms of ideographs composed of dots, lines and strokes in black ink on white paper.

The older woodblock illustrations are found in the scriptures made in Ch'ongji-sa temple in Kaesŏng in 1007. In his *Korean Buddhist Painting* Mun Myŏng-dae states that the horizontal pictures in the scripture, 10 cm by 5.4 cm, illustrate meticulously rendered scenes in which Buddha and his disciples enter the world of purity and Buddha looking for laymen, and scenes in which pagodas, clouds and flowers are depicted in a skillful manner.

The woodblocks preserved in the Sajang-gak Pavilion in Haein-sa temple date from the Koryŏ period. Of the woodblocks, the scene of the embodiment of Buddha in the Avatamska (Hwaŏm) sutra (Plate 2) was rendered 100 years earlier than the woodblock illustrated by Plate 1. Plate 2 is a scene in the 72nd fascicle of the sutra showing fairies. Haein-sa temple was founded in 802 to teach the doctrine of the Hwaŏm sect of Buddhism. The temple still preserves three sets of Hwaŏm sutra fascicles. Plate 2 is a scene from a set of 80 fascicles preserved in the temple. The beginning of every set contains an illustration depicting the contents of the scriptures. In addition, the temple preserves 10 woodblocks, which are part of a set of 60 fascicles and a set of 40 fascicles.

This means that there remain in Korea over 100 woodblocks with illustrations made in the 10th century.

Among the other extant woodblock prints of the Koryŏ period are those of Buddha shown before the assembled disciples and Amitabha trinity (Plate 3 and 4). Plate 3 shows Buddha teaching on foothills of a mountain and his disciples listening to him. Plate 4 depicts Amitabha flanked by Bodhisattvas. These woodblock carvings are believed to have been made in the 11th century.

Plate 5 is an illustration rendered toward the end of the Chosŏn period from a woodblock made in 1246. The illustration has been donated by Yi Kyŏm-no to the Association of Publication. Like those of Plates 2, 3, and 4, the original woodblock is preserved in Haein-sa temple. Plate 6 shows a scene in which a man is put on trial in the world of the after-life. Like Plate 5, which shows some of the 46 judges, this scene belongs to the Siwang-gyŏng (十王經) scripture in which a man, having been tortured for 100 days after his death, admires the beautiful scene of Heaven.

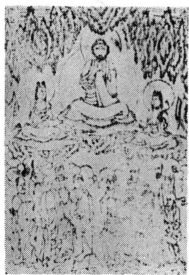

Plate 3

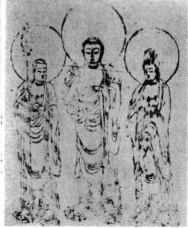

Plate 4

Plate 5 Plate 6

Among the other extant woodblock illustrations in the Sŏngam Archives is an illustration of Vajra-Sutra rendered by priest painter Pŏpkye in 1363. It is a horizontal scroll of scriptures, some 40 meters in length, with illustrations on the upper side and scriptures below. There also exists an illustration of Buddhist scripture depicting parental gratitude rendered in around 1378.

We have cited only some examples of Koryŏ woodblock prints. It is possible that we can discover many diverse and outstanding antique woodblock prints which reflect Koreans' love of learning and books and arts.

What Kinds of Woodblock Prints Remain in Korea?

It is fortunate that a considerable number of woodblocks and woodblock prints of the Koryŏ period are still in existence in Korea despite wartime destruction following repeated foreign invasions. Many of the remaining woodblocks are Buddhist in theme and this means that they have been carefully preserved in Buddhist temples. Most of the woodblock prints related to other religions, scholarly and ornamental themes are rare today because they were in the collections of government offices and high officials which were

the major objects of destruction at the times of foreign invasions.

The situation was different in the Chosŏn dynasty, however. Although foreign invasions continued in this period, the cultural properties were not wholly destroyed. There were so many woodblock prints that they have survived to the present despite continued foreign invasions.

The extant prints of the Chosŏn period can be classified into the following categories:

1. Prints on Buddhism
2. Prints on Confucianism
3. Prints on shamanistic themes
4. Prints related to politics and social life
5. Ornamental prints

Prints on Buddhism

Prints on Buddhism became increasingly diverse in the Chosŏn dynasty. Many temples made woodblocks to print sutras and illustrations. The largest number of extant prints are those of sutras and illustrations of Buddha.

The illustration of Yŏnhwa-gyŏng (蓮花經) scripture (Plate 7) appears on the first page of a scripture carved in 1536 in Simwŏn-sa temple in Hwangju. The print shows Buddha teaching Buddhist wisdom to great masses, including 12,000 monks, 2,000 Arahan laymen, Bodhisattvas, and 80,000 saints.

Plate 8 is an illustration appearing on the first volume of Pulsŏlsim-gyŏng (佛說心經) scripture made in Sangguk-sa temple in 1569. It shows the Bodhisattva of Mercy reciting the Tarani Scripture kneeling before Sakya.

In addition to Plates 2, 5, 6, and 7, there are many woodblock prints illustrating the contents of such scriptures as the Avatamska sutra, the Saddharmapundarka sutra, the Vajra (ccedikaprajna-paramita) sutra, the Sukhavativyuha sutra, Chijang-gyŏng (地藏經) sutra, Nŭngŏm-gyŏng (楞嚴經)

Plate 7 Plate 8

scripture the Vimalakirtinirdesa sutra, the Nilakanthaka sutra, Pumoŭnjung-gyŏng (父母恩重經) scripture and Moklyŏn-gyŏng (目蓮經) scripture. The Buddhist prints introduced by Sŏk To-ryun in the September, 1968 issue of *Space* included those of the Pumoŭnjung-gyŏng made in Chŭnggwang-sa temple, the Nilakanthaka sutra, and Moklyŏn-gyŏng made in Obok-sa temple in 1584. The prints of *Kwanŭm-gyŏng ŏnhae* (the Nilakanthaka sutra in Korean) made in 1630 were introduced in December, 1974 issue of the same magazine by Kim Hyŏn-sil.

Among the books with prints illustrating filial piety are Moklyŏn-gyŏng which depicts a filial daughter called Moklyŏn and the Pumoŭnjung-gyŏng that stresses filial duties to one's parents. *Sŏkssiwŏnlyu* and *Wŏlinch'ŏn'gangjigok*, both depicting the life story of Sakya, are famed books of this category.

In addition to scriptures and illustrations in woodblock, temples produced large independence prints such as Plates 3 and 4. Plate 9 shows a print illustrating the Kwŏnsujŏngŏp-wangsaengch'ŏp-gyŏng (勸修淨業往生捷徑) printed in 1781 in

Yŏngwŏn-am Shrine. Similar extant prints are a life-size image
of Kwanŭm (Avalokilesvala) in Sŏnam-sa temple (appeared in
the June, 1977 issue of *Space*) and those of the Image of
Haejogwanŭm (海潮觀音 Plate 10) in Songgwang-sa temple,
the historical remains related to Sakya, *"Hansansŭpdŭk,"*
"Dharma," and *"Simu."* Some 750 rubbings of such Buddhist
prints were exhibited by Priest Chŏnghyŏn in May, 1977.

Prints on Confucianism

There are prints illustrating the Four Books and Three
Classics and funeral services. Only a few prints illustrating
ancient rituals remain in Korea today. They include those of
ancient musical instruments and dancing, and funeral
costumes appearing in *Sanglye-pigo* (A Study on Funeral
Services).

Most valued in Korean Confucian circles were books on
ethical subjects, such as *samgang oryun* (three codes and five
moral principles in human relations). These books tend to
emphasize the importance of illustrations rather than the
texts, and among such books are the *Samgang haengsil, Sok-
samgang haengsil, Iryun haengsil, Oryun haengsil,* and

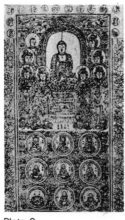

Plate 9　　　　　　　　Plate 10　　　　　　Plate 11

Tongguk sinsok samgang haengsil kŭp sokbu.

Plate 11 is a scene from the illustrations of *Oryun haengsil* made in 1796. It depicts a man capturing a tiger. Such books were compiled and printed by the government. The *Samgang haengsil* was produced in 1431 under the patronage of King Sejong. An edition in *Han'gŭl* (Korean alphabet) was also published for benefit of the general public.

The *Sok-samgang haengsil*, which was undertaken in 1512, was distributed to the public by the Ch'anjip-guk (The Bureau of Compilation). The Ch'anjip-ch'ong (The Office of Compilation), founded in 1614, published the *Tongguk sinsok samgang haengsil* in 17 volumes. Thus books with illustrations were published with all-out national efforts.

Among similar books with illustrations on ethical themes are *Kijaji* (17th century), *Hyŏngjegŭpnanjido* (17th century), *Ilbo ŭiyŏldo* (18th century), and *Sok-chŏngch'ung-nok* (19th century).

The *Sŏngjŏk-do* depicts the life of Confucius. Plate 12 is a print of the *Sŏngjŏk-do* made in the beginning of the 20th century. But there are many earlier prints taken from the same book. The birthplace of Confucius and Confucian shrines appear in the Kwŏlliji.

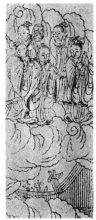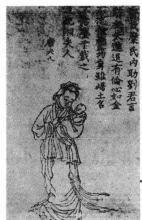

Plate 12 Plate 13 Plate 14

There also remain beautiful portraits of eminent Korean literati. An example is the portrait of Chŏng Mong-ju appearing in the *P'oŭnjip* (1410, see p. 65, the September, 1968 issue of *Space*). The collection of writings by Chŏng Mong-ju contains calligraphic works by the scholar. Portraits of poets in woodblock also appear in the collections of writings by Chinese literati.

Among the prints related to Confucian studies in *Kwihŏrae-do* (18th century) in *Táoching-chi* which was introduced by Sŏk To-ryŏn. The prints in the collection of the late Kim Sang-gi reveals the mood of the poem by T'ao Ch'ien. Illustrations of ancient novels, such as the *Sankuo-chih* and *Liehkuo-chih*, are also in existence. Plate 13 is an illustration printed in Korea in the 19th century; it portrays Madam Mi holding a child who later becomes King Houchu of the Minor Han dynasty.

Prints on Shamanistic Themes

The woodblock illustrations related to indigenous Korean Shamanism are mostly those of the Ten Symbols of Longevity by which people expressed their wish to live a long life.

Illustrations of tiger, cock and lion were often posted on the gate or kitchen to drive out evil spirits, according to shamanistic concepts. Such amulets with woodblock illustrations were produced in profusion in ancient days.

Strictly speaking, the illustrations of *Pukdu-ch'ilsŏng yŏnmyŏng-gyŏng* scripture and the 12 zodiacal animals belong to Taoist or shamanistic themes.

Prints related to politics and social life

There are prints illustrating concert scenes and official ceremonies which sometimes overlap with Confucian themes. Plate 14 is an example of concert and dancing scenes on an official occasion. Such woodblock prints are found in various books such as *Akhak kwebŏm, Chinch'an ŭikwe, Chinyŏn*

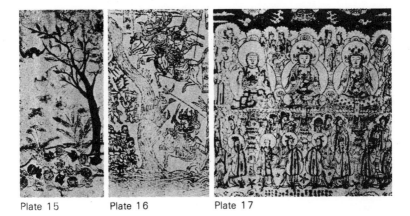

Plate 15 Plate 16 Plate 17

ŭikwe, and *Oryeŭi*.

Among the prints illustrating important government events are those of *Hwasŏng sŏngyŏk ŭikwe*, palace, and *nŭnghaeng-do*. The prints of this category also include those of warfare, weapons, *t'aekwŏndo*, and such books on medicine as *Ponch'o*, *Ma-ŭibang*, and *U-ŭibang*.

Maps are also valuable prints, but they can hardly be defined as illustrations. But the map of Kangwŏn-do in woodblock in the collection of Kim Hyŏng-bae showing scenic sites of Korea and the illustration of P'yŏngyang in woodblock are exceptions.

Ornamental prints

Plate 15, 94 by 48 cm, is part of an eight-fold screen of genuinely ornamental nature made in the 19th century. Depicted under a *bando*, a species of peach tree, are animals, bats, butterflies, watermelons and flowers. (The Immortals are said to have led a long life by eating *bando* peaches.) This print was displayed at the Korean Folk Arts Exhibition held at the National Museum of Korea in 1974.

Among the diverse ornamental prints in the collection of Yi Hang-sŏng are the stylized illustrations of Chinese characters

denoting moral principles in human relations, bamboo, flower arrangements, and cranes. (See pp. 29–33, the December, 1974 issue of *Space* magazine.)

Here we must note that lithographs and etchings also existed in Korea. I hope that these prints will be introduced in the future by some specialists.

Who Made Korean Prints? Where and How Were They Made?

Who made such diverse Korean prints? And where and how and why did they produce the prints? First of all, let us consider why prints were produced. In the case of Buddhist prints, the process of carving Buddhist scriptures and illustrations (Plates 3, 4, 9) was a means of Buddhist worship. It was no doubt important to distribute such illustrations to as many people as possible. There is a common aspect between the efforts to produce Buddhist prints for the masses and the efforts of modern print artists who produce prints in profusion to satisfy the public demand. Especially, this is true in the case of ornamental prints.

Visual effects through illustrations were emphasized in the prints illustrating Buddha and ethical themes, such as *Sŏkssiwŏnlyu*, *Oryun haengsil*, and *Iryun haengsil*. Attempts were thus made to educate people through illustrations rather than written characters. This tendency to emphasize pictures as educational materials precedes the modern Western tendency of transition from books to read to books to look at. The illustrated Bible is similar in style but differs in nature. Thus Korean prints were made for as many people as possible to show more illustrations and texts.

Then who made these prints? Prints were of course made by specialists. The specialists were called *hwasŭng* (painter priests), *hwasa* (professional painters), *kaksu* (carvers), and *kaksu pigu* (carver priests).

The Ch'anjip-ch'ong (The Office of Compilation) was founded in 1614 to produce 1600 pages of the *Tongguk sinsok samgang haengsil kŭp sokbu*. Fifty six people were employed to work under three Tojejo (senior editors). The employees included six scribes, eight painters, two *ch'angjan*, and one writer. Among the eight painters were such masters as Kim Su-un, Yi Chŭng, Yi Sin-hŭm, and Yi Ŭng-bok. It was natural that such renowned masters were employed in the publication of books of national importance. Meanwhile, skilled priest painters and carvers were mobilized by temples to make woodblocks on Buddhist teachings. Skilled painters and carvers must have been also employed when a clan was to publish private books with illustrations.

Sometimes the illustrators and carvers were the same persons and sometimes illustrations and carvings were rendered by different individuals. Inscriptions carved on woodblocks sometimes bear the names of carvers only and sometimes bear only the names of illustrators.

The painters and carvers engaged in woodblock prints were not of a learned class. They must have been genuine artisans who had nothing to do with learning. It is unlikely that scholars have ever engaged in carving woodblocks. The inscription on Plate 6 contains the names of the carvers, whereas the inscription on the Tripitaka contains both the names of benefactors and carvers, according to Sŏk To-ryun. From this fact we can deduce that the carvers were proud of their works and did not hesitate to carve their names on the woodblocks.

National publications were undertaken by a special government committee or a board of publication. Buddhist publications were generally undertaken at temples where priest painters reside, and private publications were undertaken at individual houses.

What kinds of materials and how were they used? The wood used in making the Tripitaka Koreana was birth from such places as Kŏje Island, Cheju Island, Ulnŭng Island, and

Wando Island. The woods were seasoned in the salt water for three years before carving. After carving, the woodblocks were boiled and dried in a shady place and then planed. The characters were written and illustrations were drawn on the seasoned blocks and then carved with knives. The woodblocks were lacquered and the four end pieces were ornamented with copper.

The other woodblocks were not made in the same way. Besides birch, silver magnolia and lime were also used for woodblocks and their thickness varied. Some blocks were cut horizontally and others were cut vertically. The carvers used the woodblocks with the effect of beautiful grain in mind. The names of those who seasoned the wood were sometimes listed in the inscription of woodblocks together with the names of the carpenters and carvers. Sometimes wooden handles were fixed to both ends of a woodblock for the convenience of printers.

The extant woodblocks were so elaborately made that those of the Tripitaka Koreana appear as fresh and solid as new blocks after 1,000 years of existence.

The knives used in carving had blades only on one side. Ideographs were carved from left to right. Some thin lines were elaborately carved and some strokes were crudely carved. Some carved woodblocks retain fish scale patterns as in the cases of Plates 3, 4, 7.

Fine paper made of paper-mulberry bark (*takji*) was used to make the prints. Paper of this kind could easily absorb the running effect of ink. Crude paper (*changji*) was not used. Sometimes special paper was produced to print Buddhist scriptures, but usually ordinary *takji* was used to make prints. Plate 5 is a print made on a specific yellowish paper. The effect of blurring ink is visible in Plates 2, 3, 6, 8. The blurring effect of ink was created in paper of light yellowish tones.

Printing or rubbing was as important part of the woodblock technique as carving. The craftsmen applied sufficient ink on a woodblock and applied ink again on the whole surface with

a brush. The printers placed white paper on the woodblock and placed several more papers on it and carefully rubbed the surface with a mop of horsehair or human hair. The traditional Korean method of applying wax on hair was different from the the method used in Japan.

Such a direct method of printing was used to make a rubbing from a woodblock or a monument. An indirect method was also used; in this case, a printer placed thoroughly wet paper on a woodblock and applied ink on white paper placed over the wet paper and rubbed the surface with a mop of hair and then the illustration carved on the woodblock gradually appeared. Sometimes color was added to the illustration, but more than two colors were not applied. Plate 15, which shows several colors, is an exception.

Three Patterns and Three Characteristics of Korean Prints

Plate 11 is a scene illustrating the five principles of moral conduct (*Oryun haengsil-do*). It was made in 1796. It depicts a scene in which a filial son named Nubaek captures a tiger. Though it is an illustration in woodblock, the carving is closely akin to the paintings of Kim Hong-do in composition and form. The mountain, rocks, trees, the running water, and human figures are almost exactly like those of Kim Hong-do.

We cannot see the real texture of Korean prints when they are printed in a book. But original woodblock copies are much different from the paintings rendered by Kim Hong-do on Oriental drawing paper. The effect of light colors and light ink applied on traditional Korean paintings is not effective when paintings are carved on woodblocks. We can realize that a traditional Korean woodblock artist attempted to express his own ideas with lines, forms, and compositions suitable to woodblock carving.

Among the extant Korean woodblock prints are some nearly 1,000 years old and this tradition naturally resulted in the

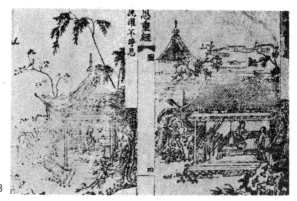

Plate 18

development of woodblock print as a unique art form, which is entirely different from painting.

As we examine the history of Korean prints and extant examples, we come to discover three patterns in this genre as in other genres of Korean art.

Plate 16 shows a scene from the *Pumoŭnjung-gyŏng* scripture carved at Yongju-sa Temple in 1976. It illustrates a mother's benevolence, her baby suckled at her breast. It was once mistaken for a painting done by Kim Hong-do. But a recently discovered inscription revealed that the Buddhist paintings and woodblocks in the temple were rendered not by Kim Hong-do but by a priest painter. The mother, her baby, the villa, and trees are meticulously carved in the manner of the painting of the Office of Painting (*Tohwasŏ*) to such an extent that it was once vaguely attributed to Kim Hong-do. Plate 18 is similar in style.

This tendency can be also detected in Plate 14, a scene of ceremonial dance and concert from the *Chinyŏn ŭigwe*. This scene is extremely realistic in the depiction of so many people, dancers and buildings. Of the 18 illustrations, three of them are rendered in this style. This realistic style is popular in the prints of Buddhist and Confucian themes and in the prints related to government administration.

People are depicted in stylized lines in Plate 14, whereas

Plate 16 features elegant lines forming the mother. These two pictures look different in style, but they belong to the same category of print in terms of the size of lines and formalized shapes.

Like the paintings in the style of the Office of Painting, these prints are highly stylized and meticulously realistic in detail, but they are refreshing in effect because of bland space left in between forms.

But the Chŏngch'ung-do (Plate 17), depicting the fight between two generals, Chŏng Kyŏn-yong and Yi Hong-su, is different in style. Entirely different from the previous illustrations are the forms of the generals, soldiers, trees, mountains and houses. Plates 8, 9, 11 are even more different in style. These prints are crude-looking and are characterized by simplification and exaggeration (as in expressionist paintings). The track of a knife with which the woodblock was carved is conspicuous and this makes the print even more coarse and vital in effect.

The crude track of knife and the coarse surface left unpolished create the effect of movement in form. Intersecting forms of straight lines and pointed carved angles arrest the eyes.

This pattern is common in many examples of Korean folk painting, folk sculpture, private houses, crude-looking pottery and wooden furniture.

Traditional Korean prints feature these two opposing qualities, realistic and expressionistic patterns. But the prints of a more or less coarse pattern constitute the mainstream of traditional Korean prints. Here I have selected more prints of this type for illustration.

Let us consider "the Meeting on the Mountain" (Plate 3) of the Koryŏ period and the Amitabha Trinity (Plate 4). We can notice endlessly varying shades of ink created by the coarse forms in a fish scale pattern.

Nevertheless, these prints retain elegant patterns as well. They eclectically combine the virtues of coarse and delicate

patterns.

Plate 8 is an appropriate example to illustrate this point.The image of Sakya is vaguely suggested in black ink, but here the linear form of the image is not emphasized.

This tendency can be detected in Plates 1, 2, 5 as well as Plates 11, 12, 16. The carved lines forming Madam Mi in Plate 13 look somewhat simple and angular, but they nevertheless present tender, feminine qualities.

The salient features of traditional Korean prints are apparent in these prints. Such patterns appear in traditional Korean painting, Buddhist sculpture, temple architecture, Koryŏ celadon and Chosŏn white porcelain. They are even akin to those found in illustrations of the Bible and other genres of Western art.

The True Beauty of the Korean Print

Then what is the beauty of Korean prints? What are the salient characteristics of Korean prints?

First of all, we find the beauty of the Korean print in its treatment in monochrome. Traditional Japanese prints in polychrome are extremely beautiful, but they do not have depth created by the monochrome of Korean prints in black ink on white paper.

We admire the wisdom of our print makers who capitalized the harmony between ink tones and white paper to a maximum degree. The carvers also realized the vitality of monochrome in woodblock.

According to Cho Myŏng-gi, carvers engaged in the Tripitaka Koreana of Haein-sa temple, carved one character and then stood and offered prayers before continuing their work. They were so sincere and devoted and this can be traced in each ideograph and detail of the woodblocks. Thus the whole-hearted devotion of woodblock artists is evident. According to Cho Myŏng-gi, skilled woodblock artists worked

for money in the carving of Buddhist scriptures in China and Japan. But there is no evidence that Korean carvers who produced the Tripitaka Koreana and other Buddhist scriptures received remuneration for their services.

Once we understand the state of mind of Korean woodblock artists who worked in disregard of money and mundane desires and honor, we can appreciate their devotion to the beauty of art in monochrome.

Western print artists number their works and mark some outstanding prints as "Artists Proof" (AP). I wonder if such an attitude can be comparable to that of Korean print artists. Western artists confirmed their satisfying prints with the sign of AP. But traditional Korean prints came to light only after a rigid examination. That is why there is no single error in the Tripitaka Koreana carved on over 80,000 woodblocks. Plate 18 shows this evidence.

Korean artists rejected colors and were only obsessed by the effect of composition, and harmony of line, form and dots.

Secondly, we cite naturalness as a feature of traditional Korean print-making. They did not work for reward. Nor did they intend to show their output to others. There was no pretence in their art. Their work reveals the candid Korean mind in which they loved and enjoyed nature. They spontaneously sought what was essential and this can be traced in their work. At a glance, their work looks as simple as nature, but we find in it infinite depth of mind. This is the essential character common in Korean arts.

Thirdly, we find in Korean prints a certain human warmth. We feel a warm touch in every traditional Korean print. It reveals the gentleness and integrity of the Korean mind; it is lovable as if a human being. We do not feel resistance against it. We feel as if we were absorbed in it. It captivates us with "a warm hand."

The longer we see it the more it is enjoyable. It does not seem to be a copy. It seems to be the sole picture "for me to see and enjoy," the sole picture mysterious alive in the world.

There is no coldness. It is not in a lofty place beyond our reach. It is full of soft, lovable qualities and is close to us.

Finally, we feel strength within the softness, the strong will of the Korean people, an explosive vitality in the crude-looking Korean prints.

We are fascinated by Korean prints and books as a living art not produced in profusion.

Kim Wŏn-yong, who organized an exhibition of traditional Korean prints for the first time in Korea, pointed out in his *History of Korean Art* that a more serious study of Korean prints is acutely needed. Traditional Korean prints have been collected, examined and exhibited by Ch'oe Sun-u, Yi Hang-sŏng, Sŏk To-ryun, Ch'ŏn Hye-bong and Ch'oe Hye-yŏng. We look forward to a more full-fledged, widespread research on Korean prints.

As we see the Amitabah Trinity (Plate 18), we feel the necessity of research more acutely. The Buddhist illustration, 50 by 45 cm, in the collection of Pak Chu-hwan, was carved in Hoean-sa temple in 1581. It looks like a Buddhist painting of the Koryŏ period. It depicts the Amitabah flanked by Bodhisattvas, other Bodhisattvas, Disciples, the Four Deva Kings, among other figures. The inscription lists the names of priest painters, priest carvers, and the priest who confirmed the carving. It is not only meticulous in composition and form. It displays the highest possible human skills in woodblock in terms of line, and in contrast between rectilinear and curvilinear lines, and in counterpoint and symmetry. It captivates us for its relaxing qualities as well.

We have so far observed the mental depth and features of Korean woodblock prints and noted the outstanding qualities of traditional prints in monochrome.

Contributors in This volume

Ch'oe Sun-u	Director, National Museum of Korea
An Hwi-jun	Professor of Art History, Hong Ik University, Seoul
Sŏk Do-ryun	A former Buddhist monk
Hong Sŏn-p'yo	Researcher, Hong Ik University Museum
Dr. Boudewijn C.A. Walraven	Senior Lecturer in Korean Studies, University of Leyden Belgium
Zo Za-yong	Founder-Director, Emille Museum, Boŭn
Kim Ho-yŏn	Professor, Sookmyung Women's University, Seoul
Kim Ch'ŏl-sun	Korean Genre Painter